CREATIVE Lettering AND BEYOND

TIMELESS Calligraphy

LAURA LAVENDER

Walter Foster

ELISHA D. SMITH PUBLIC LIBRARY
MENASHA, WISCONSIN

Brimming with creative inspiration, how-to projects, and useful information to enrich your everyday life, Quarto Knows is a favorite destination for those pursuing their interests and passions. Visit our site and dig deeper with our books into your area of interest: Quarto Creates, Quarto Cooks, Quarto Homes, Quarto Lives, Quarto Drives, Quarto Explores, Quarto Gifts, or Quarto Kids.

© 2019 Quarto Publishing Group USA Inc.
Artwork and text © Laura Lavender. Photographs on pages 5, 28, 34, 60, 64, 69, 70, 76, 84, 96, 99, 114, and 122 © Shutterstock. Photographs on pages 58–59 Bethany & Aaron Mallory (themallorysphoto.com).

First published in 2019 by Walter Foster Publishing, an imprint of The Quarto Group. 26391 Crown Valley Parkway, Suite 220, Mission Viejo, CA 92691, USA.
T (949) 380-7510 F (949) 380-7575 **www.QuartoKnows.com**

Walter Foster Publishing titles are also available at discount for retail, wholesale, promotional, and bulk purchase. For details, contact the Special Sales Manager by email at specialsales@quarto.com or by mail at The Quarto Group, Attn: Special Sales Manager, 100 Cummings Center, Suite 265D, Beverly, MA 01915, USA.

ISBN: 978-1-63322-729-3

Digital edition published in 2019
eISBN: 978-1-63322-730-9

Acquiring & Project Editor: Stephanie Carbajal
In-house Editor: Rebecca Razo

Printed in China
10 9 8 7 6 5 4 3 2 1

Contents

Introduction

IN OUR EVER-INCREASINGLY MECHANICAL AND DIGITAL WORLD, HANDMADE ITEMS—things that bear the fingerprints, experience, and the heart and soul of their creator—are especially meaningful. Part of the handcrafted renaissance has been a renewed interest in everything lettered by hand. This has spurned a gorgeous modern pointed-pen style, done with the pointed nib in an unstructured style.

Today's millennial calligraphy style evolved from traditional pointed-nib lettering, and those historical styles are the focus of this book. In the pages that follow, we will explore calligraphy exemplars from the periods when the various hands were in use. Then we will use these exemplars to study these iconic traditional calligraphy styles.

We'll focus on script pointed-pen styles of calligraphy, from the origins of pointed pen in Renaissance Italy (Cancellaresca Corsiva) to Copperplate, Bickham, Italian hand, and Spencerian. We'll supplement these traditional styles with some less common styles: pointed-pen Uncials and Roman, which are very useful for calligraphy projects.

We'll also cover the most elegant hand-lettering styles to pair with pointed-pen scripts, beginning in the mists of old Ireland with the intricate Celtic Uncial styles. We'll move to the European Medieval period and study gothic scripts. We'll also look at over-the-top Victorian embellished letters and elaborate Art Nouveau letters.

The word "calligraphy" comes from the Greek words calli *("beautiful") and* graphein *("to write"). So "calligraphy" is, by definition, beautiful writing! I'm certain that as long as people have been communicating visually, there has been both a need and desire to do it beautifully.*

How to Use This Book

THE CREATIVE PROMPTS, TIPS, PROJECTS, AND EXERCISES IN THIS BOOK are designed to inspire you to learn the art of traditional pointed-pen calligraphy. Inside these pages, you will learn how to create a variety of classic alphabets, as well as how to use them. Historical tidbits are included along the way for context and understanding of how these traditional letterforms came to be.

In Part I, you'll learn basic calligraphy terms, techniques, and terminology. You'll also discover how to work with a range of calligraphy tools and color media, set up a work station for maximum success, warm up your hand, learn basic strokes, and enjoy the creative process along the way.

In Part II, you will dive into learning the art of crafting beautiful hands and scripts, such as Copperplate, Spencerian, Italian, and many more. You'll be treated to the basic strokes of each featured hand in addition to fun practice prompts and inspiring creative exercises.

Part III is devoted to specific styles of calligraphy that are timeless and evergreen. These include a range of Victorian hands, as well as Gothic and Art Nouveau styles.

Finally, beautiful step-by-step projects demonstrate how to use the letters you have learned, while lettering templates and open practice pages encourage you to put your pen to paper immediately!

Ready to get started?

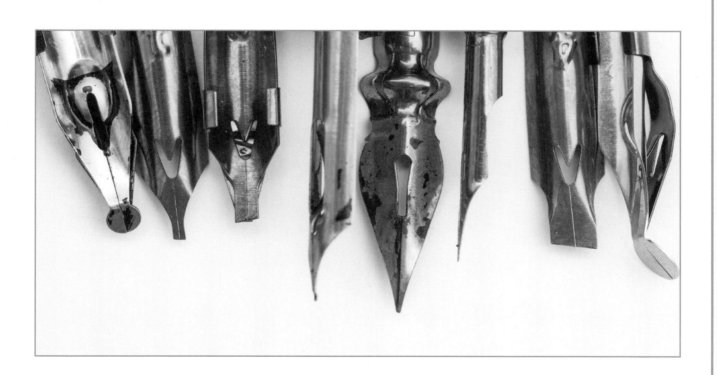

Part I:
Getting Started

Calligraphy is a craft that does not require many tools or materials. All you need to begin is a pen, nib, ink, paper, and practice!

Calligraphy & Lettering Basics

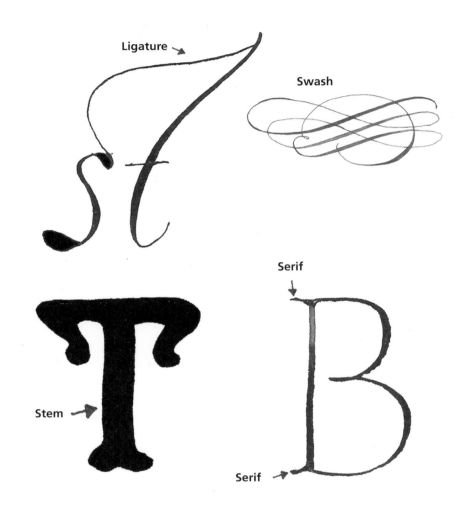

Ligature

Swash

Serif

Stem

Serif

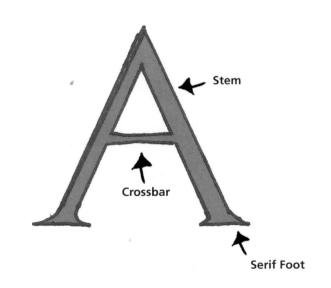

Stem

Crossbar

Serif Foot

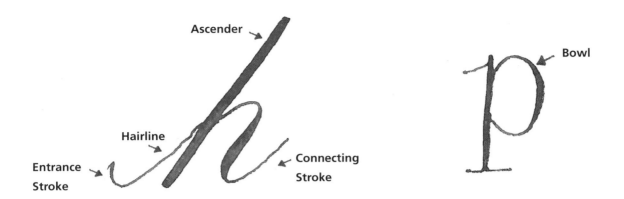

Ascender

Bowl

Hairline

Entrance
Stroke

Connecting
Stroke

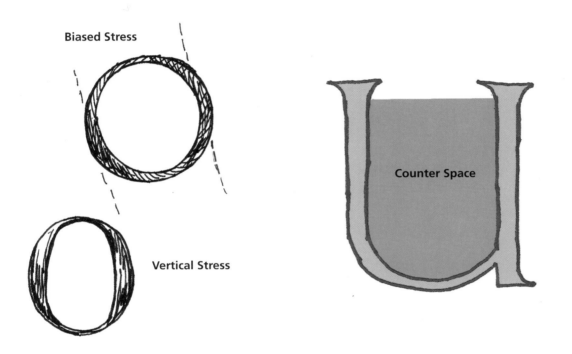

Biased Stress

Vertical Stress

Counter Space

Void

The Importance of Lines

Lines are important in lettering for practice and learning, as well as for creating finished pieces.

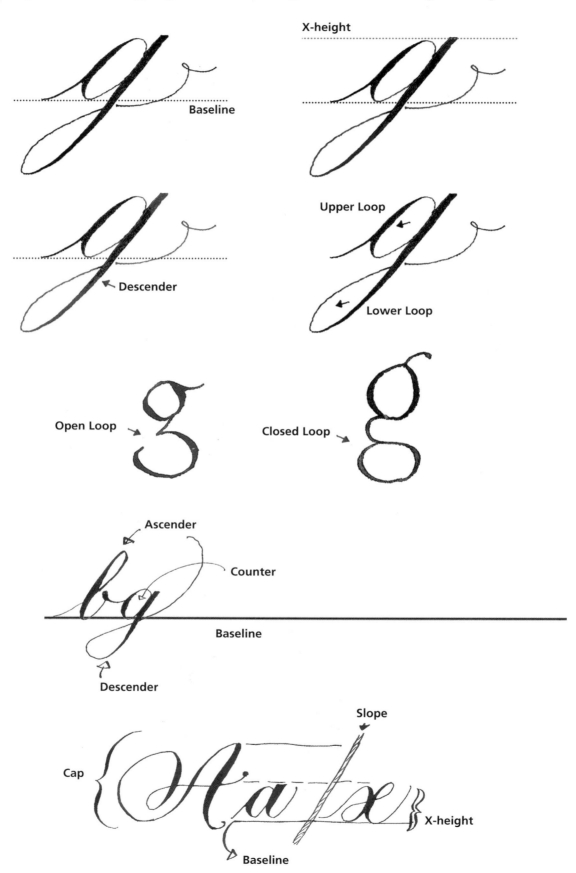

There are four key lines in calligraphy: baseline, x-height, cap height, and slant line. These lines are arguably the most important aspect of creating beautiful and legible calligraphic art.

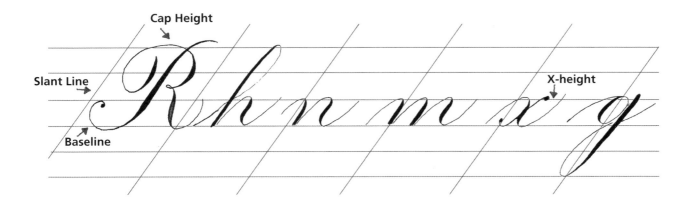

- The baseline is the line upon which all the letters rest.
- The x-height is the height of a small letter "x" placed upon the baseline. When creating letters, it's a priority to keep them nicely placed along the baseline, and to keep all the x-height letters within the x-height.
- The cap height is the height of the capital letters, or majuscules.
- The slant line is the line at which the letters are sloped. Keep all downstrokes at this angle.

General Points

- The slope of the letter—the line that shows the angle at which the letter has been constructed—is vital for defining the style of the lettering, as well as maintaining its fluidity.
- Letters written in a very upright fashion—no slope—tend to have a more casual feel.
- Highly slanted letters have a more formal feel.
- Maintaining a consistent slope among all your strokes—that is, maintaining a similar angle of all heavy downstrokes—is key to creating a unified look. As a general rule (and rules are meant to be broken, but that's another story!), keep all downstrokes on the same slant line.
- Traditional script pointed-pen styles have a fixed slant line that must be followed to maintain the look of the hand.
- Modern calligraphy has no fixed slope line, which adds to its individuality.
- Always use lines when writing. This is so important to creating elegant calligraphy. As you become more comfortable and practiced with your calligraphy and lettering, you may only need to use a baseline.
- Using a light box, or other lighting setup, allows you to see guidelines without having to draw them on the page. A light box is worth its weight in gold to a calligrapher!

Tools & Materials
Basic Calligraphy Materials

Pen Holder

I recommend an oblique pen holder, but you may wish to try a straight pen holder. Plastic calligraphy pens are available at most art stores, but choose a turned-wood holder if you can find one and would like to invest. Make sure your chosen nib will fit your holder.

Nib

You need at least one pointed-pen nib. If you're not sure where to start, I suggest Hunt #56, Nikko G, Hunt #101, and/or Gillott #404.

Ink

Black ink, such as an India ink, is opaque and permanent. Look for Japanese sumi ink, if possible, which is formulated especially for calligraphy and sumi painting.

Paper

The best paper for basic pointed-pen calligraphy is smooth white drawing paper. Look for Bristol or bond paper. If you plan to add watercolor or gouache washes or illustrations, use 140-lb. or heavier watercolor paper, and learn about paper stretching.

Choose hot-pressed paper for your watercolor calligraphy projects. Hot-pressed paper is machine-made and run through hot rollers, creating a smooth surface.

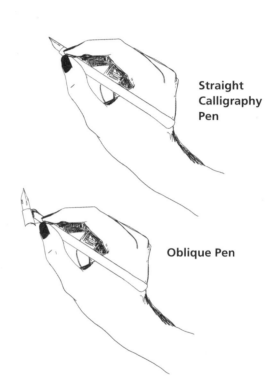

Straight Calligraphy Pen

Oblique Pen

Other Basic Supplies
- Small jar, fitted with a sponge to clean your nibs
- Ammonia or alcohol to clean pen nibs
- Old toothbrushes (for cleaning nibs and pens)
- Small glass jars for decanting ink and mixing colors
- Light box

Improvising a Light Box
If you're not ready to invest in a light box, here are some alternatives:
- Place a piece of clear glass or plexiglass on an easel and arrange a light source behind it.
- Work at a glass-top dining table and place a light underneath.

IMPORTANT:
Calligraphy dip pens and fountain pens are not the same thing! Avoid fountain pen ink for use with your dip pen. Fountain pen ink is dye-based and generally does not perform well with dip pens. Dip pen ink is pigment-based; it is much thicker and waterproof when dry. Never put dip pen ink in a fountain pen! It will clog and could ruin a fountain pen.

Watercolor & Gouache

Watercolor and gouache are among the best ways to color lettering and calligraphy. Watercolors have a transparent quality that allows for layering and creating washes. Choose white or light colored paper for use with watercolor.

Gouache is opaque and can be used on dark or light paper. White gouache is excellent for writing on a dark surface. Gouache also comes in a range of metallics.

To use gouache or watercolor with your pointed pen:
Squeeze the paint into a small dish, jar, or palette, and add a tiny bit of water. Use a paintbrush to mix the paint to an ink-like consistency, similar to coffee creamer; then use a paintbrush to load the paint onto the back of the nib. Test your nib on scrap paper to ensure good flow prior to placing your pen on your writing surface.

Paints are available in tubes and pans and come in student-grade and artist-grade. You should always buy the best quality you can afford. Artist-grade paints are made from high-quality pigments, resulting in a denser watercolor and better lightfastness. If you're just starting out, student-grade paints will still give you lovely results.

Additional Materials
These items are other perfect additions to your arsenal!

- White and metallic gouache paint
- Paintbrushes
- Needle-nose pliers (for adjusting nibs and flanges)
- Pen holder with adjustable flange to suit a range of nibs
- Soapstone pencil (for marking black paper)
- Black eraser (for erasing on black paper)
- Kneadable eraser

- Gum arabic, binding, and thickening agent
- Gum sandarac (for dusting glossy paper to repel water)
- Phantom-line™ lettering guide
- Tracing paper
- Walnut ink crystals (lovely sepia ink made from peat)
- Oak gall ink

Pen Holders & Nibs

Pointed-pen holders are either oblique (in which the pen nib is held at an angle) or straight. Each style creates a different writing angle. The oblique holder positions the nib at an angle that facilitates a 35- to 55-degree slant required for formal pointed-pen styles. The straight holder can be used at any angle, depending on the position of your hand and the nib. Additionally, a straight pen holder can be used with other nibs, such as broad-edged nibs, which are used to produce other calligraphy hands. It's helpful to have both a straight pen holder and an oblique holder.

Try out different nibs to determine which works best for you. There are a variety of different pointed-pen nibs available. Some nibs are made of stiffer metal and require more pressure to create a thick stroke. Others are made of more flexible metal and require a more delicate touch. All calligraphers have their own collection of nibs, with their favorites in rotation.

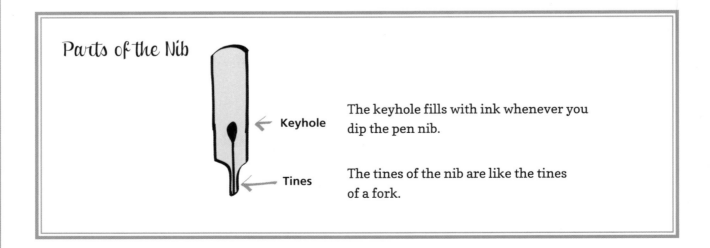

Parts of the Nib

Keyhole

Tines

The keyhole fills with ink whenever you dip the pen nib.

The tines of the nib are like the tines of a fork.

The Pointed-Pen Nib

The pointed pen comes to a sharply pointed, fine tip.

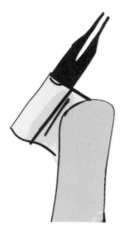

The pointed-pen nib works through pressure. The more pressure placed on the nib, the more the tines separate. The separation of the tines allows more ink to flow out, creating thick swells. When you glide the pen along the paper without pressure, you create thin, elegant hairline strokes.

All the calligraphy and lettering in this book is done with a pointed pen. (Although, the embellished lettering can also be done with a fine black marker, if you prefer!)

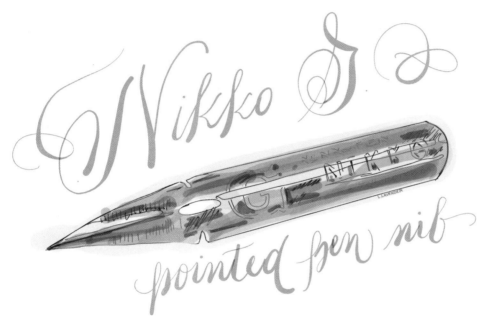

The Nikko G (shown above) is a large, sturdy, stiff pointed-pen nib. This Japanese nib is frequently recommended for beginning calligraphers. Because we all hold our pens differently, various nibs produce different results, depending on the user. Sample as many nibs as possible. Here are some suggestions:

- Brause 361 Steno
- Leonardt Shakespeare
- Leonardt/Hiro Crown #41
- Leonardt Index
- Zebra G
- Brause Rose #76
- Hunt 100
- Leonardt/Hiro 700
- Gillott #291

Attaching a Nib

Ensure you position your nib correctly in your pen holder. The keyhole needs to point upward, and the tines need to be equally weighted on the paper.

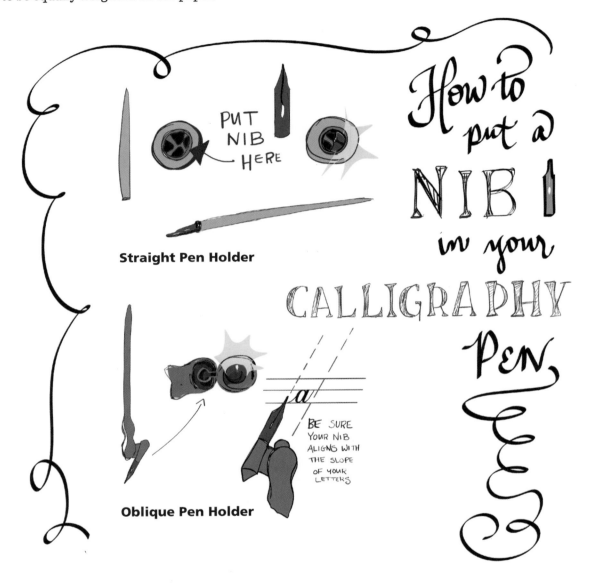

Straight Pen Holder

Oblique Pen Holder

PUT NIB HERE

How to put a NIB in your CALLIGRAPHY PEN

BE SURE YOUR NIB ALIGNS WITH THE SLOPE OF YOUR LETTERS

When to Replace a Nib

If you notice the tines of your pen nib are splayed, bent, chipped, or rusted, it's time to replace it. Be attentive to when your nib is scratchy, noisy, or generally difficult to use, as these could be signs it is past its prime. Lightly bent tines sometimes can be repositioned with needle-nose pliers.

Dipping your Pen

When dipping your pointed pen, ensure the keyhole is submerged in the ink, as this aids in ink retention and longer strokes. Do not dip the pen holder in the ink. After you dip the nib, practice a stroke on scrap paper to ensure that it is not overloaded with ink. Look for too much ink buildup in the back of the nib. If this happens, gently wipe the ink back into the jar.

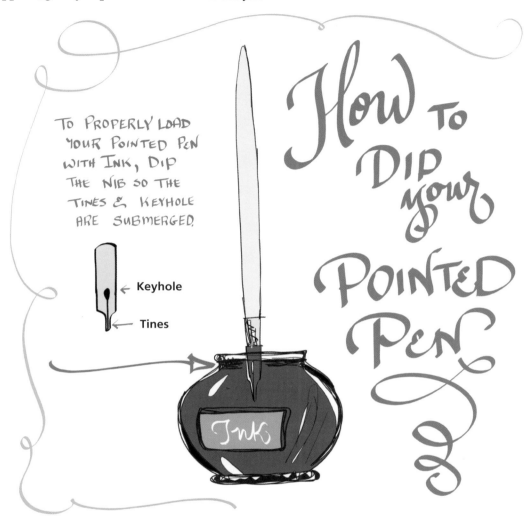

TO PROPERLY LOAD YOUR POINTED PEN WITH INK, DIP THE NIB SO THE TINES & KEYHOLE ARE SUBMERGED.

← Keyhole

← Tines

How to Dip your Pointed Pen

Caring for Your Nibs & Pens

Basic maintenance of your pens and holders will help them have a longer life:

- Never leave nibs or holders soaking in water.
- Keep your pen nibs and holders clean. In between dipping the nib in ink, give it a wash in a jar of water regularly. This will keep the nib clear of dried ink, which can inhibit the flow. Keep a towel nearby to dry your nib prior to dipping again.
- When needed, give your nib a scrub with an old toothbrush and some dish soap. Rinse well, and ensure that the nib and pen holder dry thoroughly. If your nibs are really dirty, cleaning them with ammonia should do the trick.

A brand new pen nib needs to be cleaned prior to use. Most nib manufacturers coat the nib to prevent damage in transit. Some calligraphers recommend passing the pen nib through the heat of a match or lighter, and then wiping with a cloth to remove the coating. I simply give the new pen nib a little toothbrush scrub.

Work Environment

Your environment is important to your success in calligraphy. For example, if you practice with bad posture, you may find the whole calligraphy experience uncomfortable or even painful for your neck, back, and shoulders. Here are some tips for creating a comfortable environment for maximum productivity.

Posture Aim for a relaxed body position and a straight back. Loosen arms and wrists.

Writing Hand Keep your writing hand free and agile on the paper so that it glides as you write. Avoid planting your hand like a tree; instead, envision a light "butterfly" hand.

Setup Keep supplies, such as ink, water, paper, etc., to the side of your writing hand. Place some extra paper under your writing paper; padding will improve your pen's performance. Use a guard sheet or a small scrap of card under your hand to avoid transferring oils from your hand to your working paper.

The Sweet Spot Keep your work positioned in a straight line in front of your heart for best posture, control, and visibility. Arrange your arms, body, and paper so that you can most comfortably work in the "sweet spot."

Lighting Position yourself and your light source so that your body, arms, and hand are not casting a shadow on your work.

Work at an Angle Keep your work positioned at an angle on a drafting table, light table, or a board propped on your lap.

Tips for Left-Handed Calligraphers

1. Try a variety of paper positions. Adjust your paper so that you can easily maintain the correct pen angle/slope, even though you may not be able to easily see your lettering. Place the paper at a 90-degree angle, and try positioning your paper farther away from your body and not directly under your chin.

2. Use an oblique pen holder. Adjust the nib in the holder at the correct position for you. Aim for both tines of the nib to be squarely on the paper, with the keyhole pointed up.

3. Try different hand and arm positions, such as overhand, underhand, or whatever feels right to you.

4. Use a guard sheet under your hand so your letters do not get smudged.

5. Try a different order of strokes from those suggested by the ductus.

6. Use other tools. Practice calligraphy with a ballpoint pen, pencil, or thin marker. These tools will let you practice letter shapes and try out hand, arm, and paper positions without the added worry of smudges and splatters.

7. Get a "left-handed" nib with an angled cut if you are working with a broad-edged nib. Pointed-pen nibs do not come with nibs styled for left-handed calligraphers. Keep your eye out for calligraphy tools specifically manufactured for the left-handed calligrapher.

8. Use a "bridge." Similar to a tiny table, some left-handed calligraphers rest their hand on this tool while they write to avoid smudges.

General Practice Tips

Calligraphy guides recommend short but frequent practice sessions—usually a half hour at a time—to avoid burnout and discouragement. Whether you are a beginner or an experienced calligrapher, the following tips and exercises on pages 20-22 will give your pointed pen a great workout!

Warm Up Warm up your calligraphy muscles by making some easy strokes (see page 20).

Techniques Once you feel warmed up, move through the essential technique strokes from the Copperplate tradition. These are key to using the pointed pen (see page 21).

Stroke Exercises Pick one of the exercises shown on pages 21-22, and practice for 30 minutes.

Additional Tips:
- Practice both the individual strokes and strokes compiled into the letters.
- Write out a line of the letter "e" in your chosen alphabet, with each "e" joined to the next; then try another letter.
- Invent a few of your own practice strokes.
- Write out a list using a pointed pen.
- Use your pointed pen to write in your journal or daily planner.
- Handwrite a letter or card to one friend per month. Add a flourished border!
- Create hand-lettered gift tags. Blank tags are available at office supply stores and craft stores.
- Purchase a copy of George Bickham's *The Universal Penman* and then practice tracing the elaborate flourishes!

Tracing
Tracing is an excellent way to practice any art form, including calligraphy. Use tracing paper and a pencil for easy practice. Simply place the tracing paper over your desired alphabet or flourish, and go!

Pointed-Pen Exercises

Warm Up

Work through the casual warm-up exercises below, keeping the following points in mind:
1) Put pressure on the nib on the downstroke, and 2) Use light pressure on the upstroke.

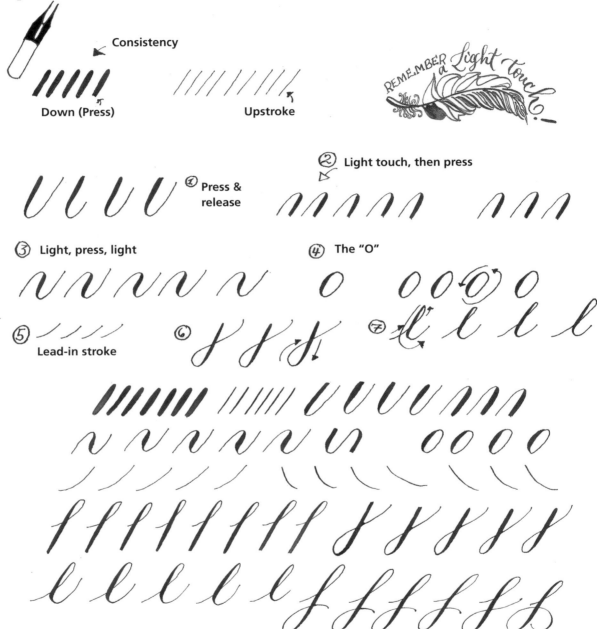

Consistency

Down (Press)

Upstroke

① **Press & release**

② **Light touch, then press**

③ **Light, press, light**

④ **The "O"**

⑤ **Lead-in stroke**

⑥

⑦

Keys to Great Lettering & Calligraphy

There are three key components to great lettering and calligraphy: spacing, slant, and size.
- **Spacing** Maintain even spacing between letters, words, and lines of text.
- **Slant** Maintain the same angle or slant in the vertical strokes of all letters.
- **Size** Maintain a consistent size in letter shapes (such as the circles and ovals that make up the letters), heights, and widths.

Techniques

The strokes below, from the Copperplate hand, are essential for working with pointed pen.

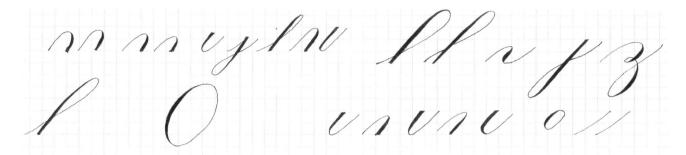

Stroke Exercises

Mountain & Valley Stroke

The most important exercise for working with the pointed pen is what I call the mountain and valley stroke. This stroke practices the smooth graduation between thick and thin; it also develops a smooth rhythm for writing.

When you are creating mountain and valley strokes, imagine creating small circles in the bottoms and tops of the strokes.

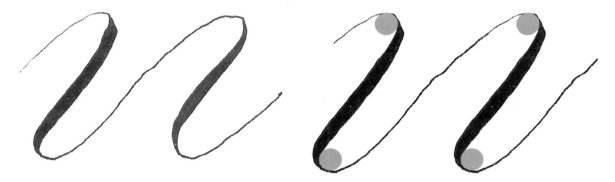

∧ Overly thick

∧ hairline

Make the swells one x-height high

Aim for evenly spaced swells and delicate hairlines

Snake Stroke

The snake stroke practices the swelled downstroke, which is important for pointed-pen majuscules. Begin with a hairline stroke and gently extend into a swelled thick stroke by gradually applying more pressure to the pen nib. Taper the stroke out into a hairline again.

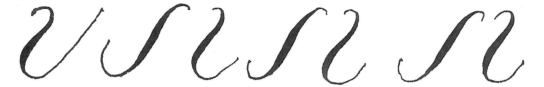

For your snake stroke practice, create a swelled downstroke; then mirror it with another, opposite-swelled downstroke.

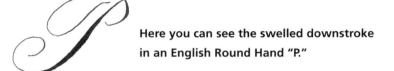

Here you can see the swelled downstroke in an English Round Hand "P."

As a beginner, warm-up exercises are vital to getting comfortable with the feel of the pen in your hand, as well as learning how much pressure to apply to achieve thick downstrokes and thin upstrokes. Don't underestimate the power of a great warm up! You'll approach your work with more ease and familiarity—and possibly save yourself some mistakes!

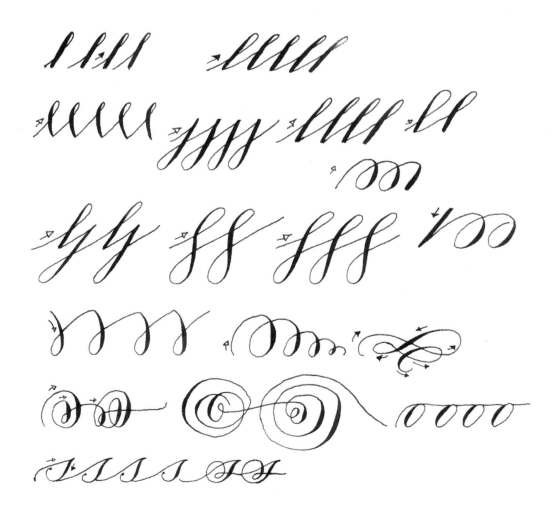

See page 25 for more about working with this template.

Pointed-Pen Script Styles

Let's take a quick look at the details and characteristics of pointed-pen script styles, which include Copperplate, Spencerian, Italian, and Bickham.

Minuscule Letter Groups

For the study of these pointed-pen script styles, we will learn the minuscule letters based on letter groups. These groups of letters are formed in a similar fashion: the entrance and exit strokes are similar, the ascender or descender formation is similar, and the pattern of strokes is the same. Many of the letters contain similar strokes and formations to other letter groups, so there is some overlap.

Generally, the minuscule letter groups are as follows:
- a, o, e, c, d, g, q
- h, l, k, b
- f, p, j
- u, v, w, x, y, z, m, n
- s, r
- i, t

Majuscule Letter Groups

The pointed-pen script majuscules, or capital letters, are different from one another. Rather than group them by shape, we'll study the majuscule letters individually from A to Z. There are, however, a few of the same strokes that are used in several majuscule letters. They are:

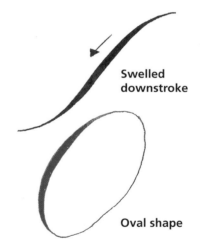

Swelled downstroke

Oval shape

- **The swelled downstroke:** The swelled downstroke begins with a hairline stroke that gently extends into a swelled thick stroke by gradually applying more pressure to the pen nib. The stroke then tapers into a hairline again. This stroke is evident in many capital letters in a variety of fashions: A, B, D, F, I, J, L, N, P, R, T, V. This is an important stroke to practice.

- **The oval shape:** The majuscule oval is formed in the same way as the minuscule oval shape. The stroke is gradually weighted as the oval is formed—as you ascend up the side of the oval, the line becomes a hairline.

Pointed-Pen Script Numbers

Numbers are best drawn roughly the size of minuscule letters (x-height). Aim for clarity in your numbers, and avoid overly embellishing them. Instead, aim to form them beautifully.

1234567890 &

Pointed-Pen Alignment

This illustration shows the ideal alignment of the pointed-pen nib, the slant line, and the downstroke. These three items should be in line for every downstroke. Keep the tines of the pen nib equally pointed along the slope line, and the keyhole centered and facing up.

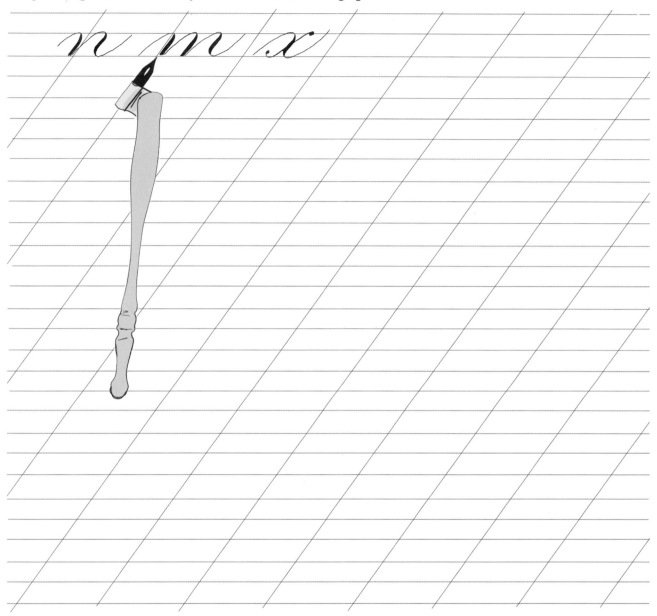

See page 138 for more pointed-pen practice templates.

The Ampersand

The ampersand originates from the Latin *et*, which means "and." Originally, this symbol was drawn to include a clear "e" and "t" joined together. These days, much liberty is taken with the ampersand. It can lend itself to some dramatic flourishing! The "e" and "t" no longer need to be clearly visible in its creation, but it's good to keep the original symbol in mind.

Spacing

Spacing is important in calligraphy. The spacing between words and between letters is essential for legibility, elegance, and style.

Spacing between letters. In calligraphy, you need to have what appears to be equal spacing between all of the letters. I say "appears" because the letters of a given alphabet are shaped differently. For example, the spacing between the letters "d" and "p" has a different shape than the spacing between "s" and "s." It's helpful to think of spacing between letters in a word as volume, rather than a measurement.

Calligraphy Tip

Look at the example of "d" and "p" below, and envision the area between them filled with water; then envision that water was poured into a cup. Would the water in the cup be same amount of water needed to fill the space between "s" and "s"? This is a useful image to remember when spacing letters.

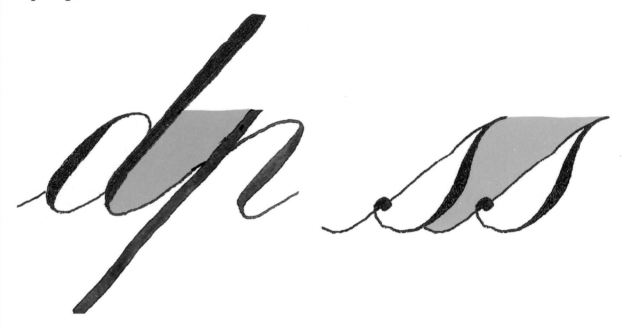

Spacing between words. For spacing between words, envision a minuscule letter "n" of your alphabet between the words.

Joining Strokes

The entrance and exit strokes on your letters are how the letters are linked into words. To join letters together, merge the exit stroke of one letter into the entrance stroke of the next. Below are some tricky letter joins. These will give you an idea of how to join them, depending on the chosen alphabet.

qu th rr rs un

um ur us uv

an ar am as

er em es ev

on or os om

br bs ss

Make Your Own Oak Gall Ink

OAK GALLS ARE ROUND OBJECTS THAT FORM ON OAK TREES. The oak galls are created by certain species of wasps. They may not be very pretty, but they make lovely ink! The below is adapted from an 11th-century recipe.

Supplies

8 oz. oak galls
Newspaper
Hammer
Glass jars (large and small)
2 1/2 liters boiling water
1 1/2 oz. gum arabic
3 oz. iron sulfate (ferrous sulfate, FeSO)
Essential oil of your choice (Naturally, I favor lavender essential oil in my ink!)
Myrrh tincture

*Supplies available online

STEP ONE Wrap the oak galls with some newspaper and bruise them with a hammer.

STEP TWO Cover the bruised oak galls with boiling water in a large glass jar. Allow to soak for 24 hours. Strain and discard the galls. (If needed, strain again.)

STEP THREE Combine a few drops of the myrrh, a few drops of essential oil, the iron sulfate, and the gum arabic in a small jar.

STEP FOUR Stir in the oak gall infusion.

STEP FIVE Bottle and label your ink.

Oak gall ink, which was commonly known as iron gall ink, common ink, or iron gall nut ink, was the standard ink used in Europe between the 5th and 19th centuries. Many ancient manuscripts were written with this kind of ink.

Part II: Pointed-Pen Hands

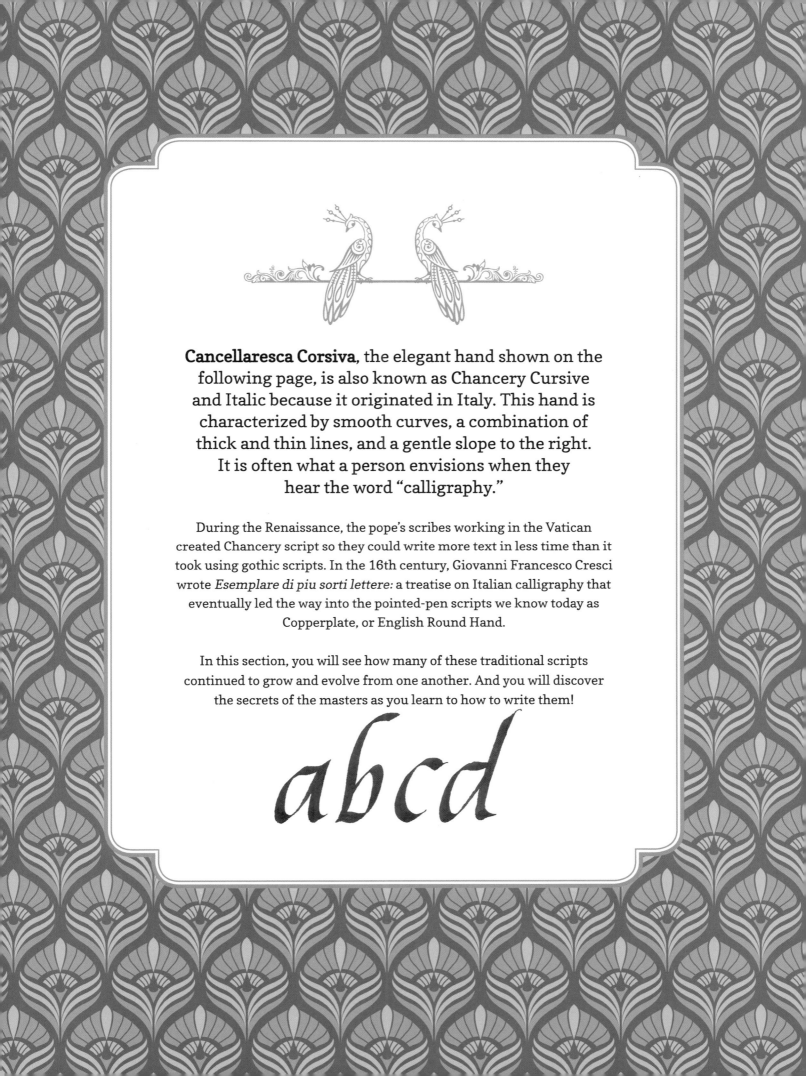

Cancellaresca Corsiva, the elegant hand shown on the following page, is also known as Chancery Cursive and Italic because it originated in Italy. This hand is characterized by smooth curves, a combination of thick and thin lines, and a gentle slope to the right. It is often what a person envisions when they hear the word "calligraphy."

During the Renaissance, the pope's scribes working in the Vatican created Chancery script so they could write more text in less time than it took using gothic scripts. In the 16th century, Giovanni Francesco Cresci wrote *Esemplare di piu sorti lettere:* a treatise on Italian calligraphy that eventually led the way into the pointed-pen scripts we know today as Copperplate, or English Round Hand.

In this section, you will see how many of these traditional scripts continued to grow and evolve from one another. And you will discover the secrets of the masters as you learn to how to write them!

abcd

The contemporary form of Cancellaresca Corsiva, shown below, is created with a broad-edged nib, not a flexible pointed-pen nib. The smooth, round curves of Cancellaresca Corsiva evolved over two centuries into Copperplate, which is also known as English Round Hand. (To see Cancellaresca Corsiva in its original form, check out the historical references listed in the Resources on page 143.)

ABCD
EFG
HJKLM
NOPQR
STUVW
XYZ

Copperplate

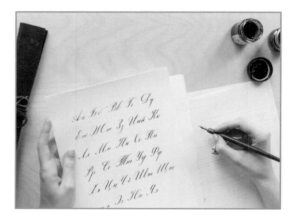

"Copperplate," also referred to as "English Round Hand" or simply "Round Hand," evolved in the 18th century from Chancery script as a way to create documents for reproduction. At the time, the method for reproducing text was engraving letters in reverse into a copper plate with a stylus. The etched copper plate was covered in ink and the plate was then pressed onto paper to create the image. The name "Copperplate" was thus born to describe the elegant hand.

Along with English Round Hand certain styles of Copperplate are also called "Engrosser's script" and "Engravers script." These styles feature a slightly different minuscule.

Copperplate Specifics

- Slant of 55 degrees
- Based on an elongated oval shape
- Ascenders and descenders are one x-height in length ("t" is slightly shorter; "g" is a bit longer)
- The majuscule letters are three x-heights tall
- Written slowly
- Lots of "finger action"

Copperplate (English Round Hand)

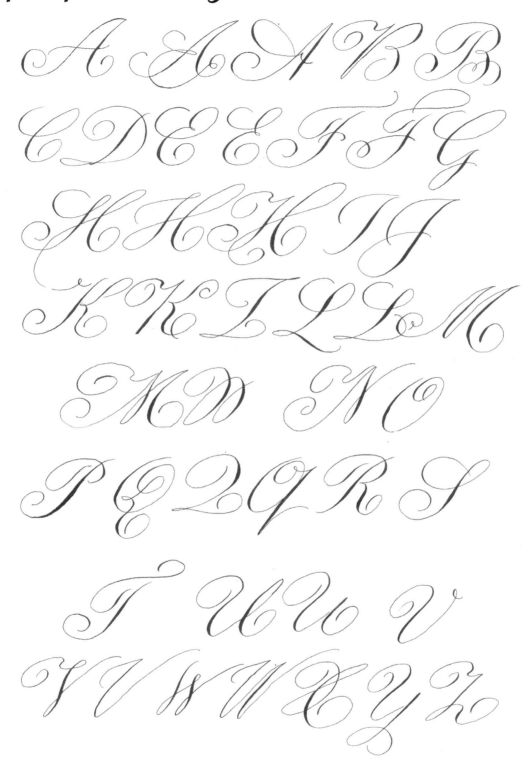

Huntington's Art of Penmanship, *an 18th-century writing manual, is a wonderful historic reference for Copperplate.*

Copperplate Strokes

Focus on the Oval

English Round Hand is based around an oval shape. This oval is also key to many other calligraphy hands, so it is a great shape to practice.

This oval is technically called an "elliptical oval," because it can be divided into four sections. If you folded the oval in half, both widthwise and lengthwise, it would match up.

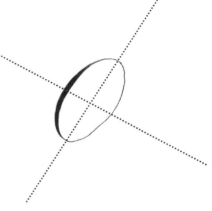

This uppercase "B" demonstrates how to envision the ovals in the counter spaces of these letters. There are also ovals in the smooth curves of the letter stem.

Swelled Downstroke
The swelled downstroke is another important stroke to practice while learning Copperplate.

Copperplate Main Strokes

Let's take a look at the four main strokes for this alphabet. Once you're familiar with these strokes, drawing the letters will be much easier.

U Shape

With the pen nib at the top of the x-height, press to spread the tines of the nib and bring the pen downward with pressure. This line should align with the slant of the hand (55 degrees). Once your pen is at the baseline, remove the pressure and glide upward in a hairline stroke, making a smooth u-shape, returning the nib to the top of the line.

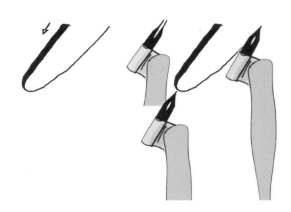

Elliptical Oval

Begin by placing your pen nib at the top of the x-height. Come down, with graduated pressure, to make a smooth shade. This shade should move from a hairline into a swell, and then back into a hairline as you approach the baseline. Finish the oval with a hairline stroke back to the top.

Upside-down U

Beginning at the baseline, move the pen upward, following the 55-degree angle. Once you reach the x-height, begin curving the pen nib to the right. As your nib makes its descent, apply pressure gradually to create a solid, thick stroke.

Swelled Stroke

One of my students calls this wavy, swelled stroke the "snake stroke!" This one makes up one of my favorite pointed-pen exercises, called "mountain and valley." Draw a graduated stoke that goes from a hairline to a swelled shade, then back to a hairline. Aim for a smooth, gradual thin-thick-thin line.

You can add to these main shapes with additional strokes. These are the strokes we'll use as the building blocks of the minuscule alphabet. By putting together several of these strokes, we can assemble the entire alphabet of small letters.

Practice these and you'll be set! Follow the arrows, as shown here, to create these strokes.

Remember to make smooth, oval-shaped curves. Apply gentle pressure on all downstrokes, smoothly moving in a thin hairline for upstrokes, with no pressure.

Copperplate Letter Groups

To maintain a unified look in your writing, and to understand the construction of the letters, it's helpful to identify how letters are similar to each other. We can group together some of the minuscule letters based on these similarities.

> ### First Group: q a c o e d g
> This group is unified by the oval stroke.

ag	The letter "g" is simply letter "a" with a tail added. Be sure to keep the loop in the tail of the "g" the same size as the other looped descenders.
co	Letters "c" and "o" take the same amount of space. "C" is simply a letter that hasn't been made a complete oval—be sure to add the dot!
e e	The letter "e" takes up the same amount of space as the letter "o."
d	The letter "d" is a letter "a" with an ascender.
adg	When making the letter "d," envision the letter "a" with a taller stem. For the letter "g," envision letter "a" with a long, looped descender.
q	Add a descender tail on the letter "a," and voilà—"q!"

plht

Second Group: p l h t

This group is unified by a tall stem.

n

Third Group: n m y / h p

The letters "n," "m," "y," "h," and "p" include a "u" stroke like the one shown at left.

Fourth Group: g j y

All of these letters have looped descenders.

The letter "z" has a looped descender, but in the Round Hand alphabet it is slightly wider than the other descenders.

Copperplate Practice Exercises

The n alphabet

Write the full minuscule alphabet, with a minuscule "n" between each letter. Minuscule "n" is an important letter to have firmly entrenched in your hand's "muscle memory," because it's the letter we envision between words when spacing our writing.

Single-letter Row

Try a full row of a single letter, without lifting your pen. Minuscule "n" is a great letter to choose for this exercise.

S Stroke

Practice the s stroke.

Mirrored S

For this exercise, practice making a mirrored "s." After drawing one "s" in the usual fashion, draw one backward!

Copperplate Minuscules

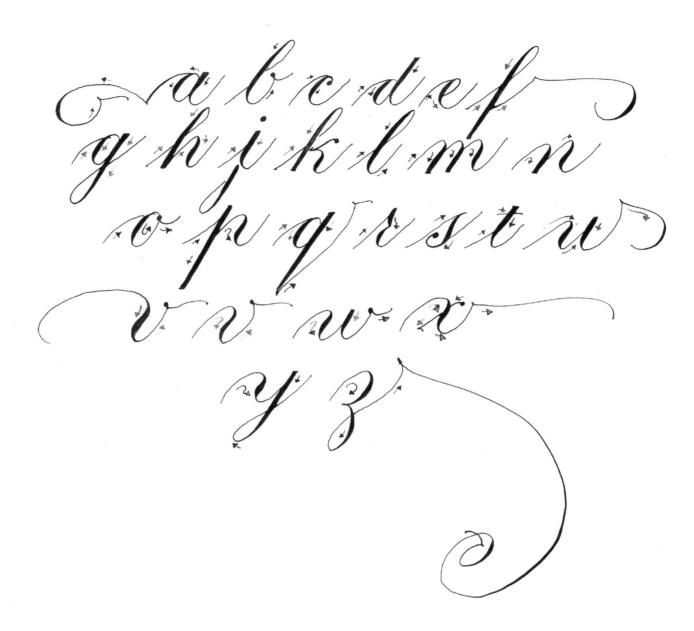

Copperplate Majuscules

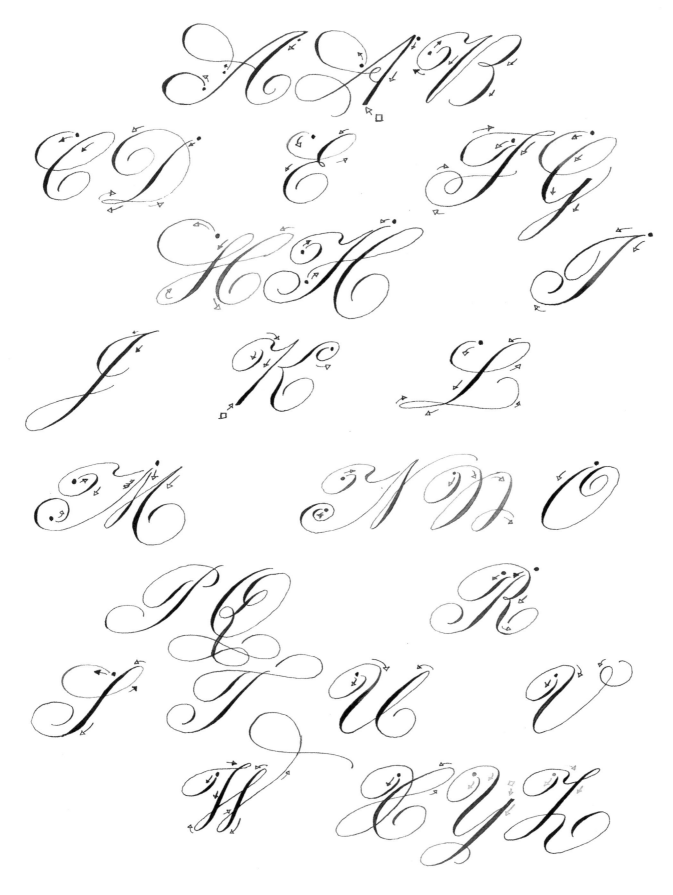

Spencerian

In the **19th** century, American writing master Platt Rogers Spencer developed a new lettering style that showed his affinity and respect for nature. This smooth hand rolls like waves and curls like elegant vines. Imagine these smooth flowing motions when practicing.

Some of the early writing manuals show Spencerian being written with a straight pen holder. I personally find this awkward and prefer an oblique holder, like the one shown here. Try both and see what works for you. If you use a straight holder, you may find it preferable to sit turned in your chair with just your writing arm on the table. A light touch with a gliding hand and arms is key to Spencerian script. You might use a guard sheet, such as a laminated or plasticized card to prevent smudging.

Spencerian Specifies

- Main slant of 52 degrees
- Connecting lines (hairlines) are at a 30-degree slant
- Rhythmic flowing movement
- Based on an oval shape
- Meant to be written quickly, with a loose, swinging arm
- The tall looped letters (h k l b) are three x-heights tall
- The descending looped letters (j y g z) are three x-heights long
- Minuscule "f" takes all five spaces
- Majuscule letters are written large, at three to four times the height of the minuscules
- Small letters are almost entirely monoline

Spencerian Majuscules

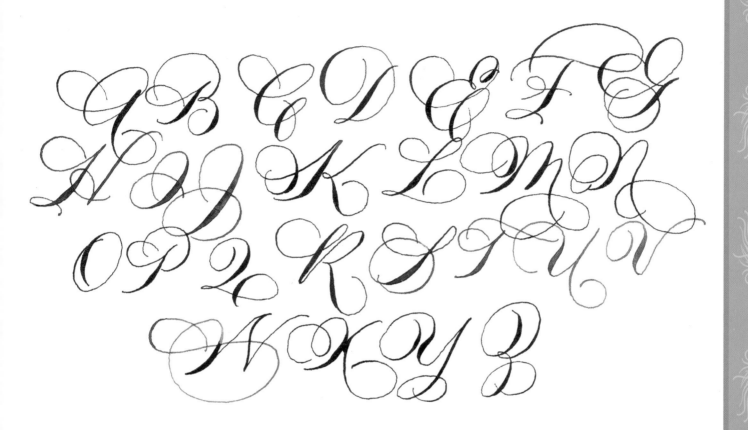

REMEMBER a Light touch.!

Practice Prompt

Minuscule Key Strokes

The Spencerian key strokes are deceptively simple. The first stroke is a line drawn at 52 degrees. The next two strokes are concave and convex lines. The last stroke is the oval.

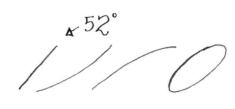

Like the Copperplate styles, Spencerian is also based on an elliptical oval.

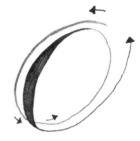

Start by writing the letters "i," "u," and "w." To create an "i," make the concave upstroke, followed by a 52-degree downstroke. At the baseline, come up again with an upstroke. Adding a dot makes this identifiable as an "i." To create a letter "u," join an additional downstroke and upstroke to the letter "i." Add on to the letter "u" with an additional downstroke and upstroke to create a "double u," or "w." The little curved line at the end is the connecting stroke to the next letter.

Now you can add to the key strokes!

Spencerian Letter Groups

Like other calligraphy hands, Spencerian minuscules are divided into letter groups based on their structural similarities. The letters divide into two general groups: 1) ascenders/descenders, and 2) all the small letters.

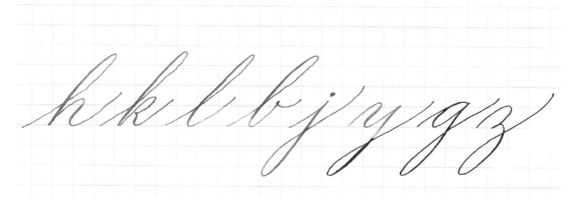

These letters have ascending and descending loops.

	In the small letters, "i," "u," and "w" are based on a "u" shape.
	The letters "n," "m," "x," and "v" are all based on smooth, curved downstrokes and the 52-degree line.
	The letters "o," "a," and "c" are based on the elliptical oval.
	The letters "t" and "d" have a slight amount of shading at the top.

Spencerian Practice Exercises

1. N Exercise

The "n" exercise (or, as it was called in the past, "cross drills") is a traditional Spencerian practice exercise. This exercise consists of creating a smooth minuscule "n" in one continuous line, followed by an identical line below until you have created eight lines. Turn your exercise one-quarter turn clockwise, and begin the same exercise on top of the other lines, with each letter "n" falling in between the other lines. You can also do this exercise with other minuscule letters, such as "m," "o," and "a."

2. Spencerian Oval Exercise 1

For this exercise, draw the letter "o," making each "o" move smoothly from large to small and back again.

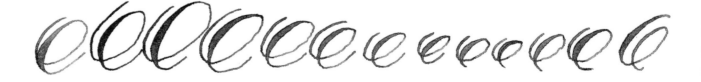

3. Spencerian Oval Exercise 2
Join ovals together with a curved, swashed line at the top.

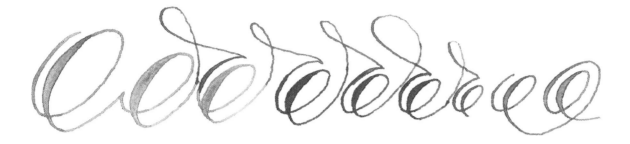

4. Spencerian Line Practice
Practice thin hairline upstrokes and downstrokes. Draw the downstrokes at 52 degrees.

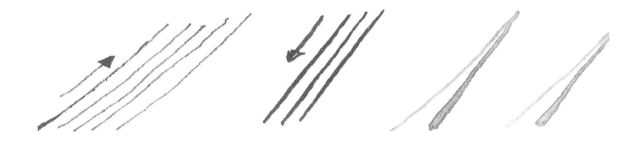

5. O Exercise
First make smooth, even lines of the letter "o," aiming for them to be the same size and distance apart.
Next draw a string of the letter "o," followed by a letter "l," another string of "o", and the letter "b."

6. J-u-s

Join the letters "J," "u," and "s" in smooth loops and downstrokes at 52 degrees.

7. Building Blocks

Practice the Spencerian stroke building blocks.

8. Letter Groups

Practice writing the letters in their letter groups. Be attentive to the similarities in each letter group, and keep those consistent across all letters. For example, keep all the descender loops the same size.

Spencerian Majuscules

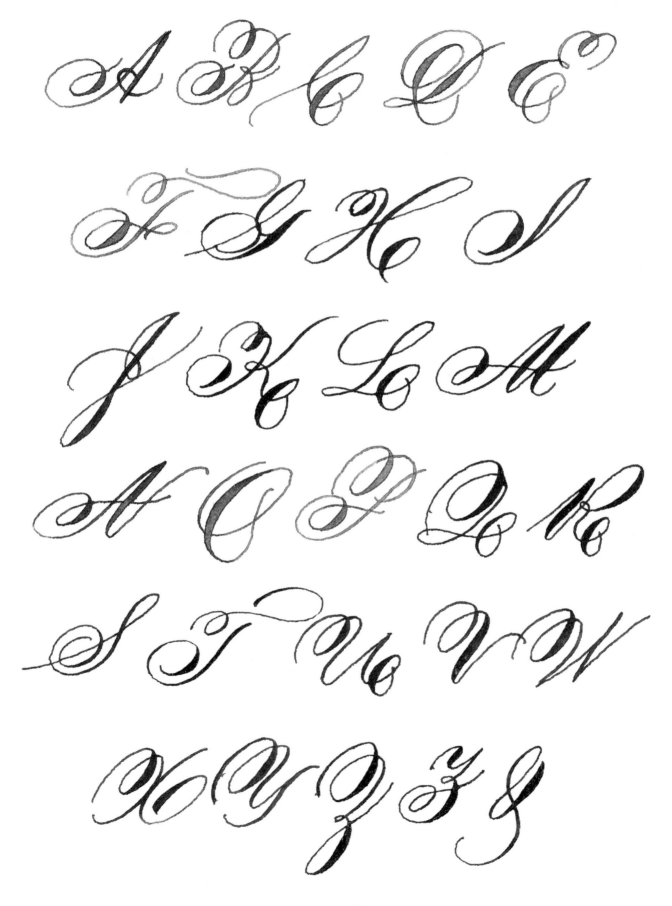

Monograms & Wedding Invitations

WANT TO CREATE GORGEOUS MONOGRAMS AND WEDDING INVITATIONS? Use these techniques as a guide to get you started!

STEP ONE Decide which monogram style and design you would like. Will you do a non-traditional arrangement, a single-letter design, or a classic three-letter monogram?

STEP TWO Sketch your letters on separate pieces of tracing paper, one letter per page. When creating multi-lettered monograms, it's helpful to work this way, because the tracing paper can be physically layered, allowing you to easily and quickly create various arrangements until you find the one you like.

STEP THREE Once you're pleased with your design, finalize with pen and ink!

Keys to Great Monogram Design

When planning your monogram, aim for even distribution of letters, swashes, and loops. This will create symmetry and balance in the design. If you're creating a traditional intertwined monogram, leave some elements of each letter overlapping the other letter(s).

Here are three separate designs for a three-letter monogram using the letters "B," "L," and "D."

A

B

C

I rework my rough monogram sketch to include thicker swashes and add greater contrast and emphasis.

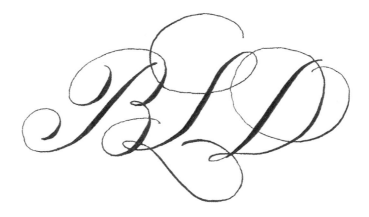

I finish the monogram by surrounding it with stylized acanthus leaves.

The acanthus is a classic and timeless foliage design.
This highly stylized foliage decoration has been in use
since the Roman and Byzantine eras.

Wedding Invitation Basics

Etiquette Tips for Invitation Wording

- Names and places are written in full on the invite. No abbreviations, except for Mr., Mrs., and Dr.
- If the ceremony is at a place of worship, the wording "...request the honour of your presence" is used. The word "honour" is spelled the Anglican way.
- Spell out dates and times fully. Do not use a.m. or p.m. Instead, use "in the morning," "in the afternoon," or "in the evening."
- If a certain dress code is requested, use the wording "Black Tie," "Black Tie Encouraged," or "Casual Attire Welcome."
- It's optional to include the year of the wedding on the invitation. (My opinion: Include it!)

Steps to Creating a Calligraphy Invitation

STEP ONE Create a pencil draft of your rough design on scrap paper. For a traditional invitation design, aim for a balanced and symmetrical composition, paying attention to word length and placement. Have equal-sized margins on either side of the invitation, and a slightly larger margin at the bottom. For a wedding invitation, ensure the focus is placed on the couple's names, either by writing them slightly larger or adding flourishing, and keeping a bit of extra white space around the names. (Tip: While this invitation design is balanced, the flourishing could use reworking where it descends into the lower lines of text to improve readability.)

STEP TWO Create a pen and ink draft. Following your draft wording, write each line of the invitation with left adjustment—that is, don't worry about centering the wording, just write each line starting from the same alignment point. Use the same sizing you will use for the finished design. (Tip: Write the design in your most comfortable size script; then have the piece reduced to suit the print size.)

STEP THREE Grab your scissors! Cut out each individual line from your pen and ink draft. Draw a vertical line down the center of a new sheet of paper, as well as horizontal guidelines. Paste the lines onto the new sheet of paper, centering the phrase both horizontally and vertically. Now you have a perfect mockup of your invitation!

STEP FOUR Now you can create your good copy. Using a light box, trace your mockup. Then scan and print. Be sure to have your design scanned and saved in the file format requested by the printer—frequently, this is a high-resolution PDF.

Always create designs for reproduction
in black ink on white paper.
This ensures the best reproduction.

The pleasure of your company
is requested at the marriage of

Marie
&
Elliott Li

May 6 2018
at half past six o'clock
Maple Bay Manor

1437 Maple Bay Road
Duncan British Columbia

Wedding Invitation Gallery

I created this wedding invitation in a loose style I call
"casual copperplate."

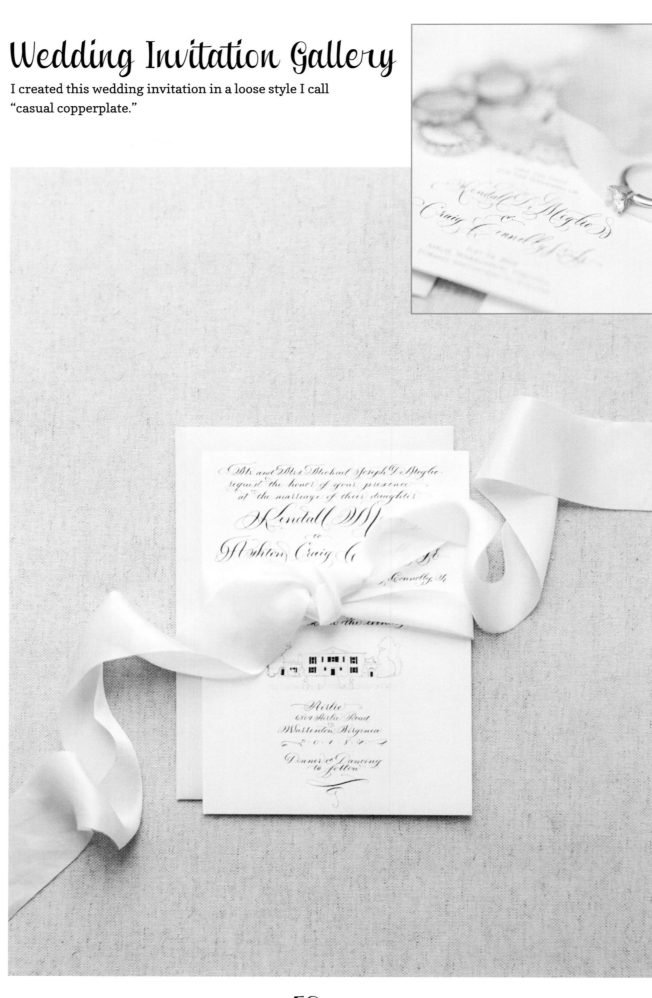

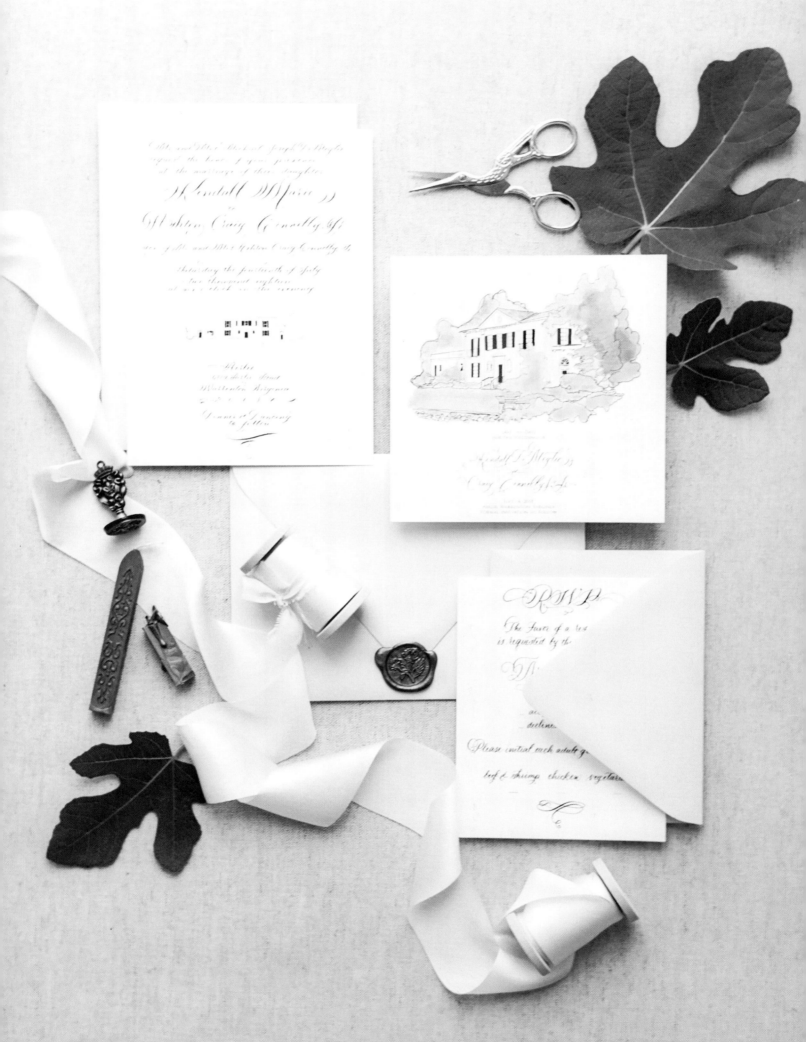

Italian Hand

AS WITH A FEW OTHER ASPECTS OF CALLIGRAPHY, there is some ambiguity over the term "Italian hand."

The name is used to describe several different scripts. I use the term to refer to a style that is based on Copperplate, yet is distinctly different! The minuscules have ink "blobs" and strong Copperplate overtones. I compiled the majuscules from several "Italian hand" resources that feature the distinctive "backward" shades. The shaded areas in these majuscules are, for the most part, opposite from the placing of shades in English Round Hand.

Italian

Italian Majuscules

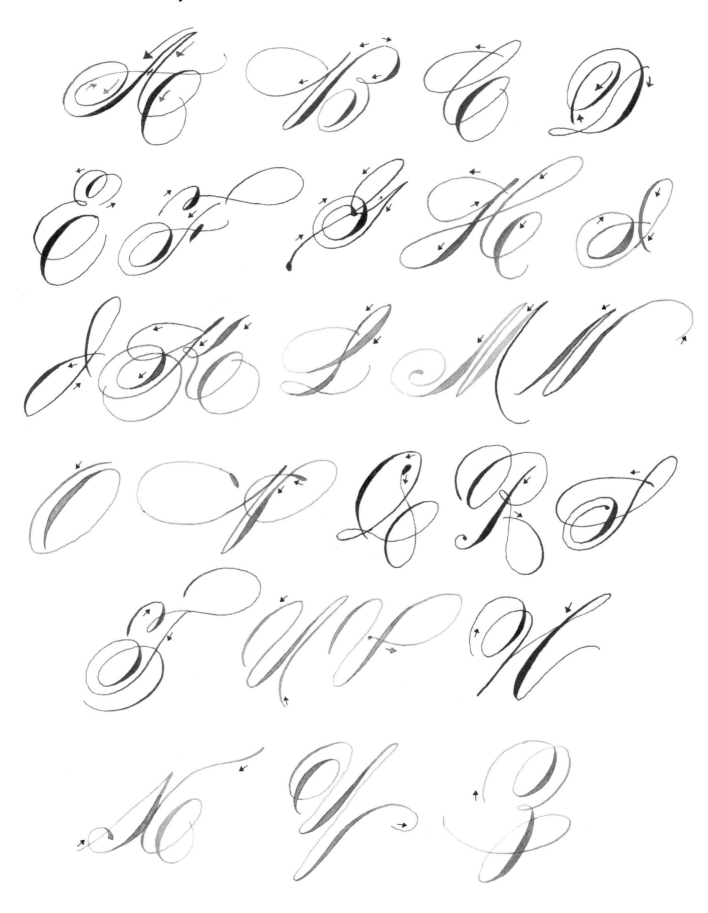

Italian Hand Strokes

Shading

The shading is in different locations than in other pointed-pen styles, so give your hand (or head) a good shake and get ready to do something new! For instance, look at this minuscule Italian "b," and notice that the distinctive oval-shaped ink blob is created with a backward loop, which is filled in by the overlapping of the pen. This elongated, oval-shaped shade is present in many of the Italian letters.

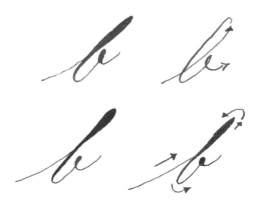

Construction

Some of the letters are constructed in a unique method. For example, to make the majuscule "B," begin with a swelled stem stroke that starts at the top of the stem and goes down into the flourish. Then place the pen nib back at the beginning of the stem stroke and continue in the opposite direction to finish the "B."

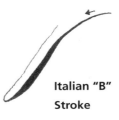

Italian "B" Stroke

Variation

As shown here, there is some variation in the way the oval-shaped letters are constructed and shaded.

62

Italian Minuscules

Bickham

The Universal Penman is a collection of calligraphic pieces prepared in the 1740s by George Bickham, a noted engraver and calligrapher. He chose some of the best examples of calligraphy and provided notes about how to write the hands in the best possible fashion. Still in print today, this book is highly recommended for any "calligraphile." The alphabet shown in this section is based on the Round Hand examples that Bickham included in his book. The majuscules feature distinctive curved strokes, while the minuscules feature straight descenders.

a b c d d e f f g g h i j
k k l l m m
n o p p q r s f t u v v
x x y y z z
1 2 3 4 5 6 7 8 9 0

Bickham Entrance Strokes

This hand requires an entrance stroke to join to previous and subsequent letters.

To follow the ductus, create your entrance stroke; then move your pen nib in the directions shown by the arrows.

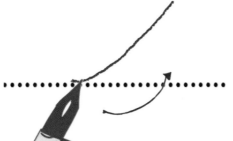

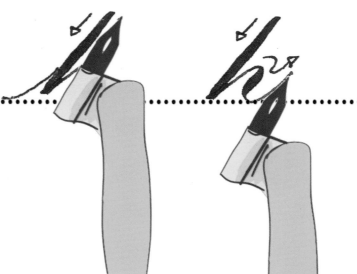

If you find that your nib starts "catching" the paper or making scratchy sounds with each stroke, it might be time for a replacement. Nibs do not last forever. Other signs the nib might need replacing: bent tines, rust, and difficulty making strokes.

Bickham Majuscules

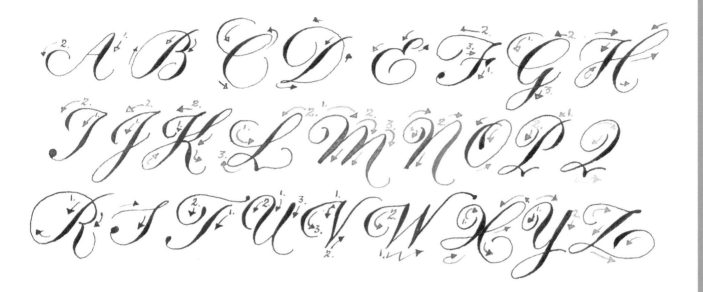

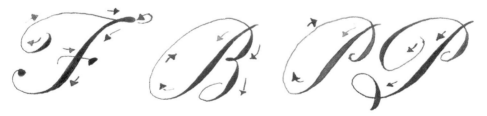

These alternate majuscules show some interesting variations in letterform!

These elegant letters are used as a base for many typefaces.

Craft a Feather Quill

A QUILL IS AN INTERESTING AND UNIQUE WRITING TOOL. There are many methods for preparing a feather and cutting the quill shape.

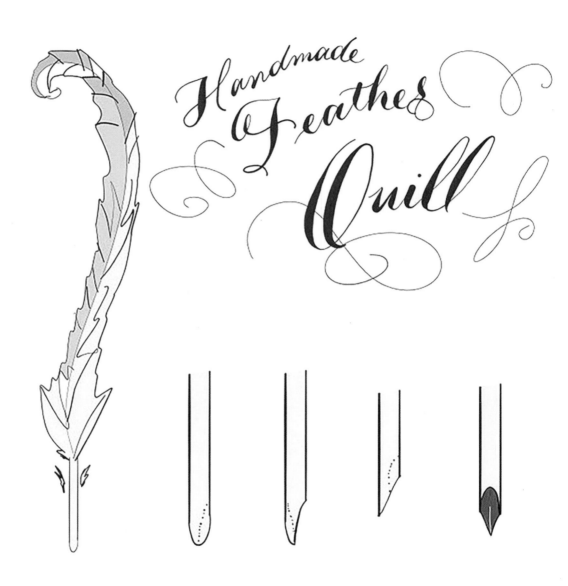

STEP ONE Choose a feather. Some people find naturally shed feathers in areas where large birds live, so keep an eye out if you are a hiker! Just keep in mind that many states have laws and regulations about collecting feathers, so be sure you're allowed to do so! Otherwise, you can use a synthetic feather or order one from a breeder.

If ordering a genuine feather, make sure you only source from a responsible, ethical breeder.

A feather from a large bird is preferable. A large feather also has a large calamus (feather shaft), which is easier to work with. The finished quill will also have a larger pen point.

STEP TWO Next prepare the feather. Feathers are naturally soft, not unlike human nails. To cure the feather, it needs to be dried and hardened. I have had success with feathers that have been left to dry for months. To hasten the process, a traditional method of curing feathers is to soak the calamus in water overnight, and then place the tip of the feather for a few seconds in warm sand.

STEP THREE Remove extra feathers from the base of the feather to allow room for your hand to hold the quill. Gently shave away the feathers with a sharp knife.

STEP FOUR Squarely cut off the rounded tip of the feather. Now you can make your quill! Hold the feather in your writing hand as it naturally seems most comfortable—this will be the way you shape the pen. Move the feather to your nondominant hand and make a curved cut on the right side of the pen. Then make a curved cut on the other side. Turn the pen upside down and cut away the belly of the pen. Lastly, with the pen still upside down, trim and perfect the pen nib. Cut a slit for the tines and square off the tip. You can cut the nib with a wide tip for a broad-edged quill or to a sharp point for a pointed-pen quill.

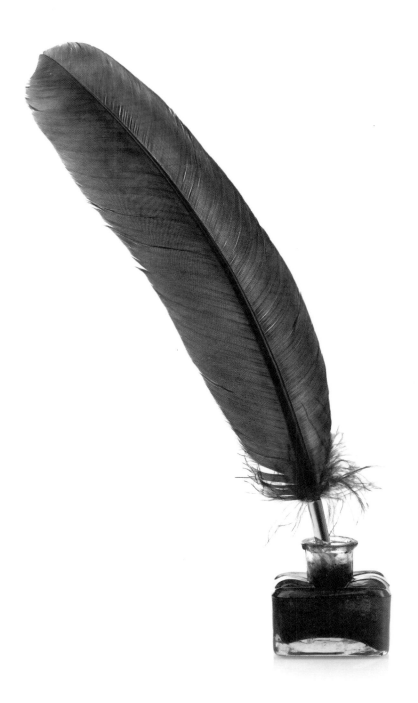

Roman

THE ROMAN HAND HAS A LONG AND INTERESTING HISTORY. It has survived through the centuries because it's easy to read, the creation of the letters is logical, and it can be written at any size.

The Roman alphabet can be created in myriad ways, including drawn with pen or pencil or lettered with a brush, broad-nib pen, or pointed-pen nib. For this hand, we'll follow traditional Roman creation guidelines, but letter them with a pointed pen to create a clean, easy-to-read alphabet.

Roman Letters

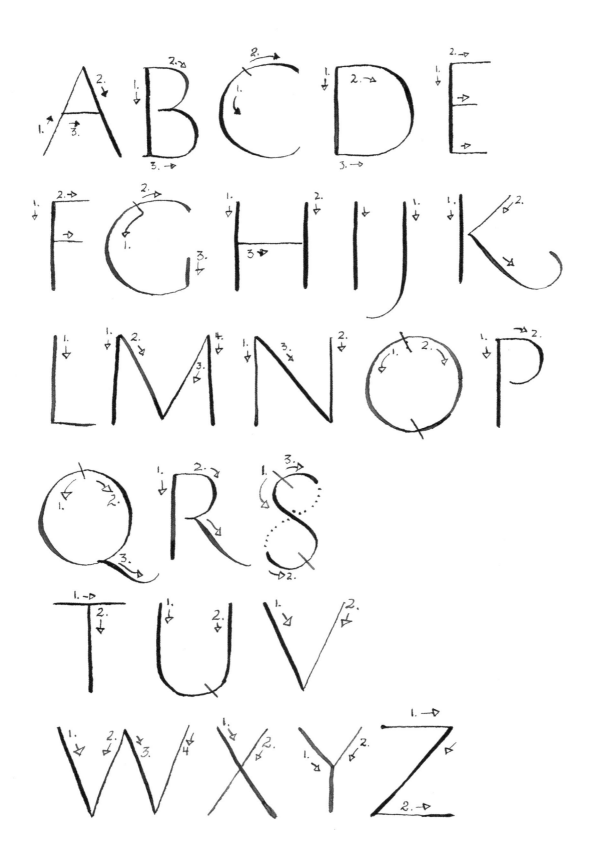

Roman Strokes

Think in Squares

Roman letters follow specific proportions related to the sizing, not the shape—all round Roman letters take up a square shape.

These letters fill half a square:

L E F B P S R

These letters fill a rectangle, slightly wider than half a square:

H T U N A
V K X Y Z

Round letters fill a square:

O C G D Q

Below are the key strokes that make up the Roman hand.
Practice these to get familiar with the motions of writing this alphabet.

I D ⌐ ⌐ ⌐ \ O

These thin letters are only a single stroke thick.

These wide letters extend outside the square.

Notice that the "W" is slightly wider than the "M."

Crossbars

Another detail of the Roman letters is the positioning of the crossbars. In the letters "H," "B," and "X," the crossbar is above the middle line of the letter. In the letters "F," "P," and "A," the crossbar is below the middle line of the letter.

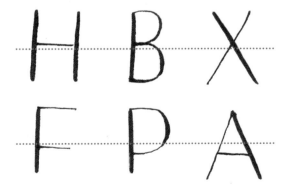

Fancy Romans

Shown here are "fancy" Roman letters. I drew these freehand, working slowly with short, sketch-like movements. I suggest drawing them at two inches or higher to capture the details. If you like, place a piece of tracing paper over the letters below and trace over them for practice.

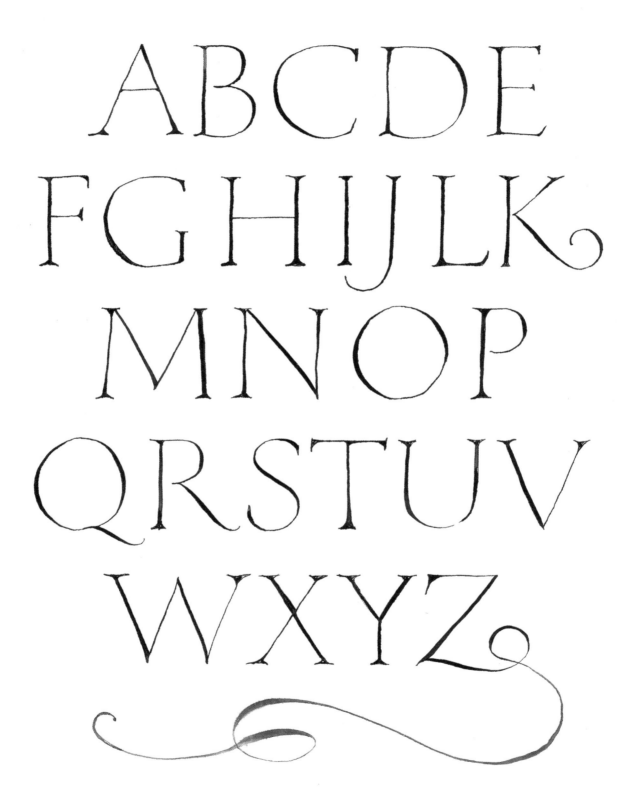

Trajan Roman Versals

These Trajan versals are an elegant way to begin text or break up text blocks, or to embellish as unique standalones.

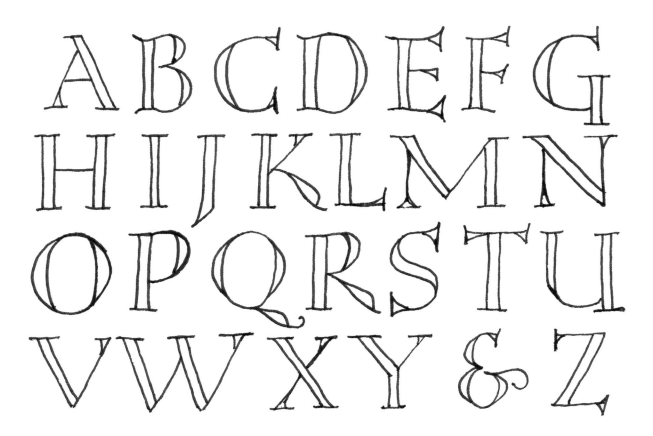

ABCDEFG
HIJKLMN
OPQRSTU
VWXY&Z

Trajan Roman Strokes

Below are the Trajan Roman strokes to build the letters. The stem strokes ever so slightly curve toward each other.

UNCIAL

UNCIAL (PRONOUNCED "UN-SHUL") IS ONE OF THE OLDEST HANDS. The letters have elements of both majuscules and minuscules that are wide and round. The ascenders and descenders are short in keeping with the majuscule style of the alphabet.

Uncial Specifics

- Letters are based on a circle
- Letters are traditionally short
- Letters circle, curl, and coil
- Letters can be serifed

Uncial Letters

The Uncial letters below are similar to traditional Celtic letters and were written with a pointed pen. They are also often written with a broad-edged pen.

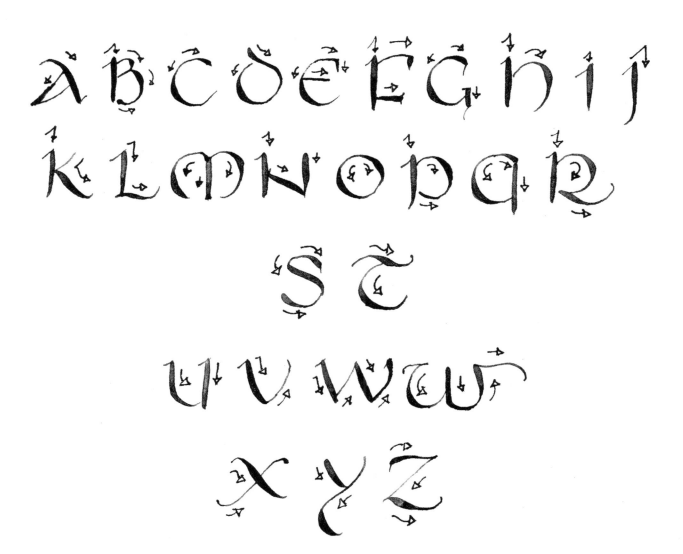

—— Tip ——

Strive for smooth, circular shapes and balance with these letters. For example, when writing the "m," endeavor to make both sides of the letter equal.

Casual Uncial Letters

Shown here is a much more casual, looser Uncial-based alphabet.

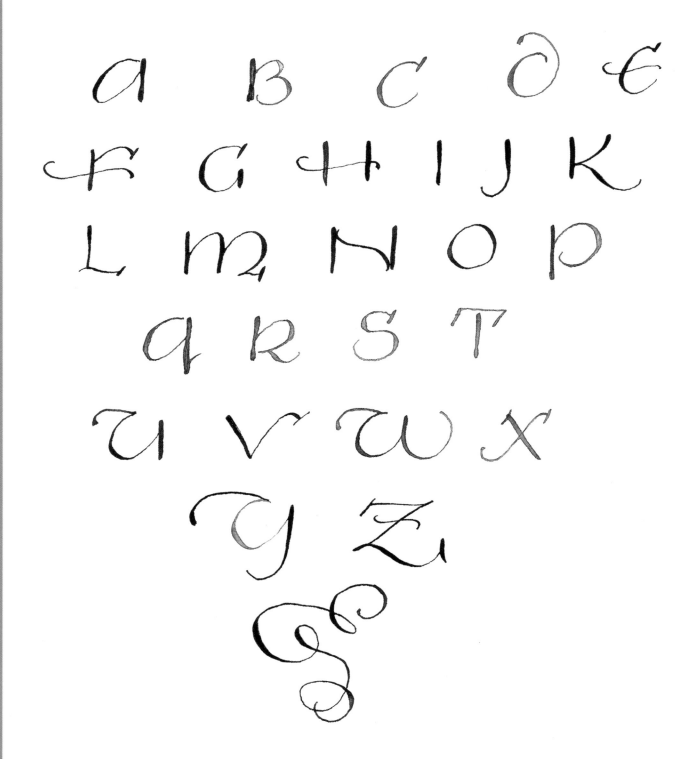

Uncial Capitals

Because Uncials originally existed in an uppercase-only format, text was divided with larger initials to begin a paragraph or page. I drew these from a 16th-century exemplar created by Spanish writing master Juan de Icíar.

ABCDE
EGHI
JKLMN
PSTV
WXYZ

Get inspired by some of the beautiful, illuminated manuscripts that feature this style of lettering, such as *The Book of Kells*, which is probably the most well-known of all illuminated medieval Gospels.

Go Big!

Practice drawing large letters, adding flourishes and embellishments as you desire. Recreate or reimagine the letters shown below, or use page 81 to work out your ideas!

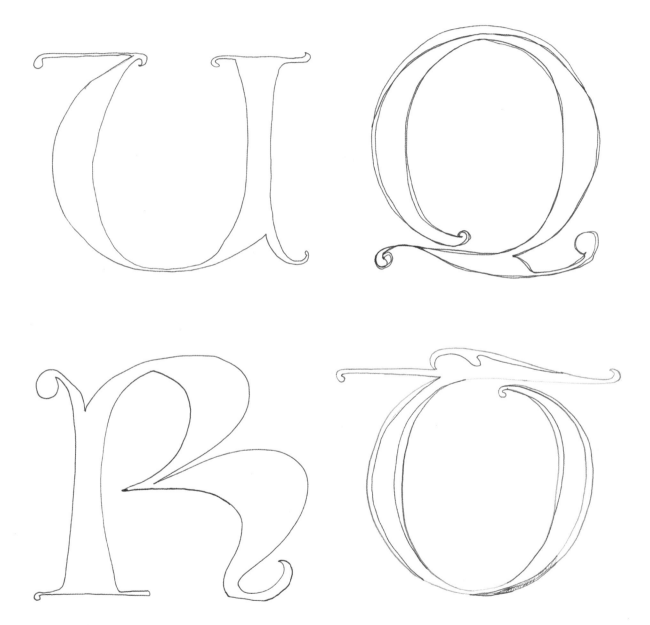

Missal

These Uncial-inspired capitals, called Missals, are a product of medieval scribes.

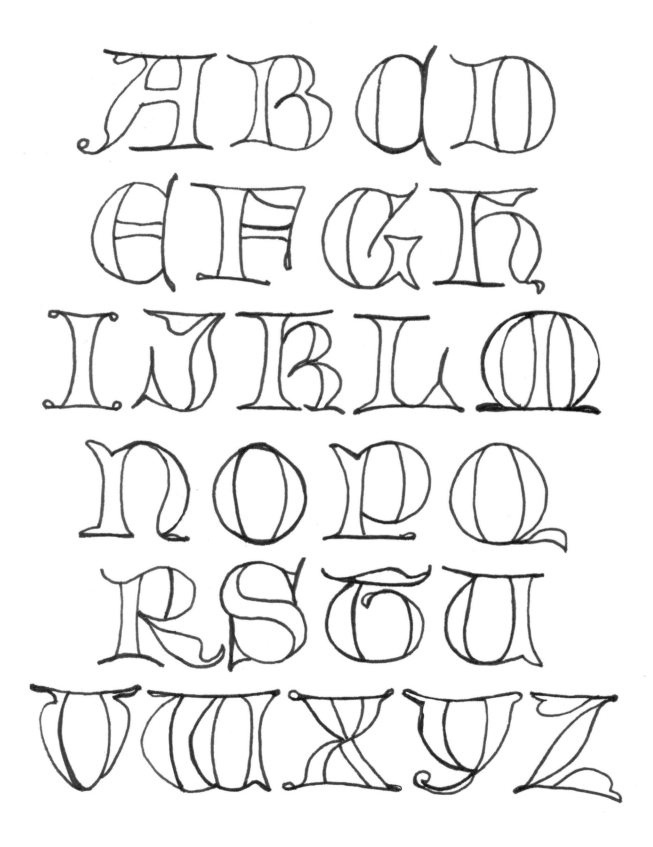

Modern Uncial Missal

This whimsical lettering illustrates a modern take on the Uncial Missal letters.

Creative Uses for Pointed-Pen Hands

Here are a few ideas for using pointed-pen hands:

- Address card envelopes in a pretty script.
- Create unique branding for your business or blog.
- Create beautiful mail art, such as an illuminated postcard or a handwritten note tucked into a beautifully decorated envelope.
- Make DIY calligraphy gifts, such as monogrammed wall art, a family crest, etc.
- Design place cards for your next event or dinner party.
- Make unique signage.

Bookhand

Bookhand originated in 10th-century English manuscripts written in what is now called Carolingian minuscule.

It surfaced again in the early 1900s when English calligrapher Edward Johnson studied Carolingian manuscripts to develop a style that he called the "foundational" hand.

Today, Bookhand, or foundational hand, is created with a broad-edged pen. For our purposes, we'll use a pointed pen to lighten the look, but still maintain the shapes.

Bookhand Specifics

- This is an upright hand
- Diagonal lines are at 35 degrees
- Keep a space of two x-heights between writing lines

Elegant Bookhand

This elegant Bookhand style features serifs and oval-shaped bowls. Make the serifs on the "feet" of the letters rounded-off strokes, with smooth joins to the body of the letter.

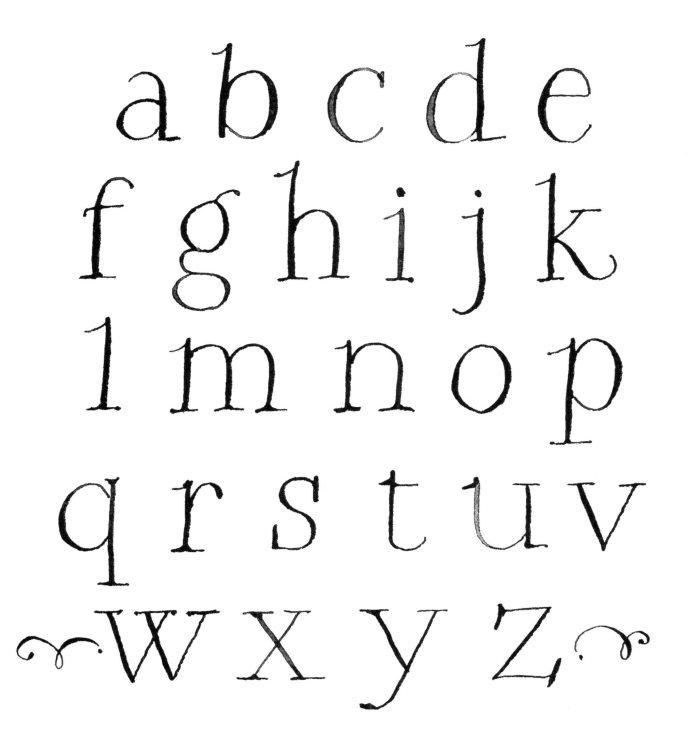

Bookhand Main Strokes

Shown below are the essential strokes for mastering this hand. Practice them before diving into Bookhand letters and numbers.

Next combine these simple strokes into this minimalistic, essential Bookhand.

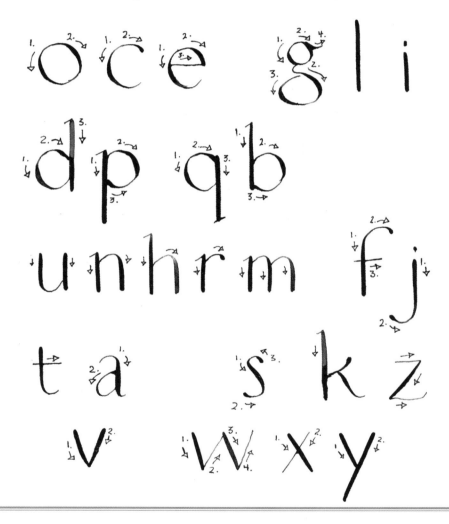

Pay attention to the crossbars when you create the letters "t" and "f." Notice how they are off-center and more to the right of the letter.

Bookhand Numerals

Next try your hand at creating numerals in the Bookhand style.

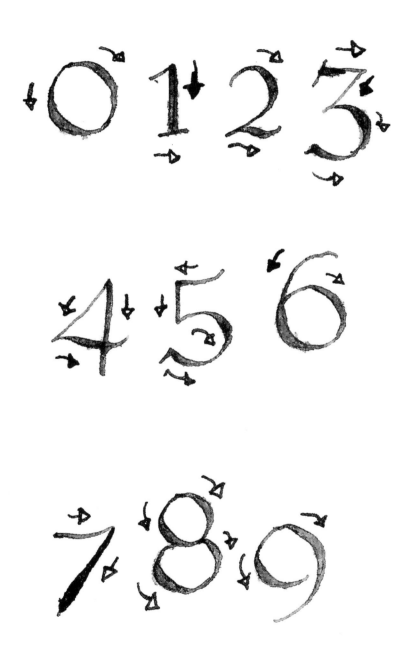

Casual Bookhand

This alphabet is a little looser and freer. Notice how the serifs are curved little loops. (Note the different "a.")

a b

c d e

f g h

i j k

l m

n o

p q r

s t u

v w x

y

y z

Bookhand Variations

Here are some fun variations to try!

Join the minuscule letters "e," "t," "c," "a," and "i" to the next letter in a word for a semi-script appearance. Joining just these select minuscules gives the writing a unique and interesting look.

etc.

curiouser and curiouser!!

Slant all letters at a consistent 35 degrees to the right for an italicized Bookhand style.

italic

Make all downstrokes extra thick, or make them very tall and narrow.

Combine variations together for a fun look!

thick & thin

absolutely fabulous!

Here are some different Bookhand ampersand styles.

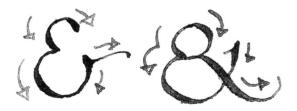

Map Inspiration

Bookhand is an excellent style to use in combination with illustrations or maps!

Print or make a copy of a map of your desired area. In pencil, trace your simplified map onto scrap paper, reworking the sketch until you're pleased. Then transfer the design to drawing paper. I traced over my draft map (below) directly onto my paper using pen and ink.

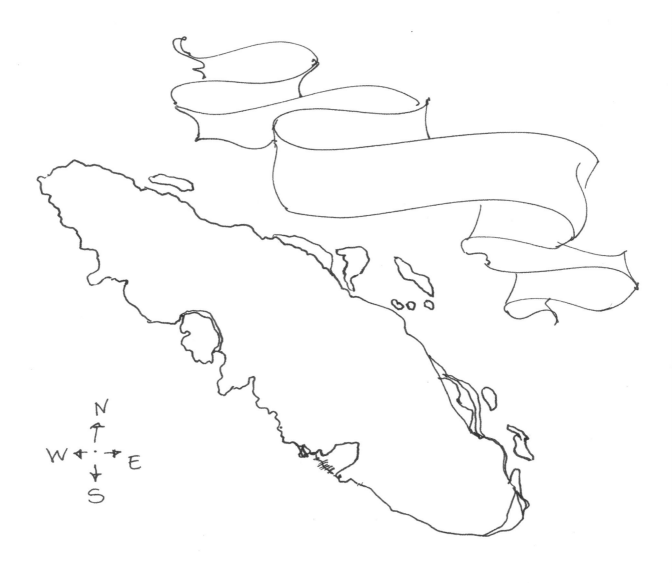

Ink your piece, working from the top down to avoid smudging your work. I like to work in sections, inking the drawings and map elements with a Tombow® calligraphy pen, and then adding the lettering in pen and ink. Allow to dry. Ta-da—a lovely map in bookhand!

Part III:
Timeless
Calligraphy
Styles

Victorian Hands

THE VICTORIANS FAVORED HIGHLY ORNATE ECLECTIC DECORATIONS IN ALL AREAS OF THEIR LIVES, including the written word. Highly fanciful hand lettering was abundant in everything from advertisements, newspapers, and legal documents to birth certificates and wedding pieces.

Envision letters encircled by serenading angels, wreathed in bountiful blooms, or worked into an illustration for an upcoming passage. In this chapter, we'll be inspired by this unique and whimsical style to draw our own letters. The Victorians drew from many historical lettering styles when creating their pieces, including Roman, Uncial, and Gothic letters.

Classic Roman Letters

Classic Roman letters form the basis of Victorian letters. Note that there are both thick and thin lines within each letter. The positioning of these lines is key to the classic Roman look, even if the contrast is not that dramatic. Additionally, notice the serifs and that the size of each individual letter in relation to the next is fixed. This means some letters take up lots of space—for example, "W"—and some take up very little space, such as "I." To draw these classic roman letters, I like to use small drafting triangles and a circle template to create smooth lines.

A B C D E
F G H I J
K L M N O
P Q
R S T U V
W X Y Z

Origins of Embellished Letters

Some letters didn't exist for the Romans (J, U, and W). By embellishing these letters with florals, decorative elements, and illustrations, we can recreate lovely—and easy to read—embellished Victorian letters!

Basic Shapes

This shows the shape of the classic roman serifs.

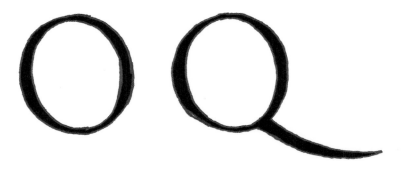

The shape of the letters "O" and "Q" are important. Notice how the weight of these letters—the thickest part of the line—is off-center.

Compare the placement of the thickest part of the line in a classic Roman "O" (top) and a modern Roman "O" (bottom).

Victorian Embellished Capitals

During the Victorian era, embellished letters—similar to the ones shown here—emerged as a way to weave story into art. These letters often included characters, animals, objects, and floral motifs.

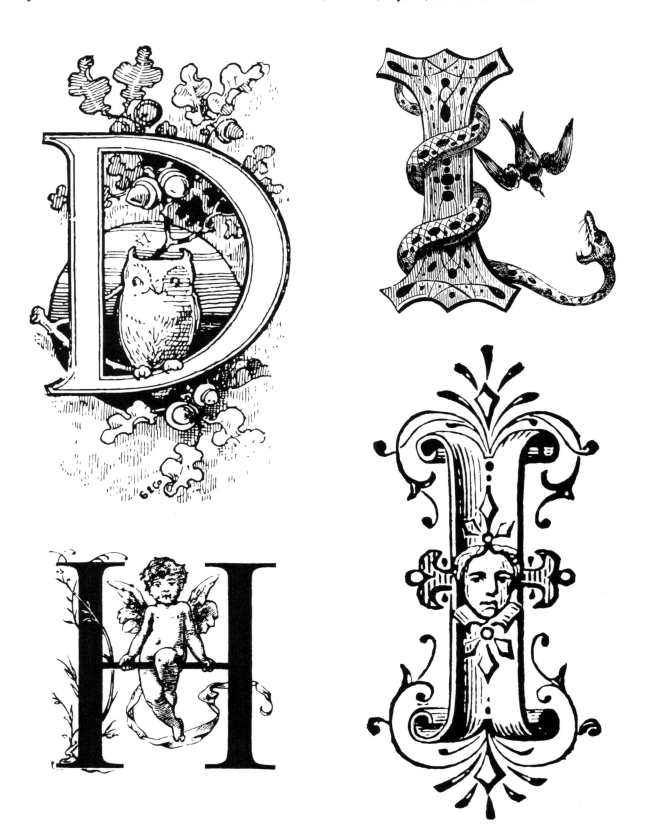

Quintessential Victorian Letters

To me, these are the quintessential Victorian letters. Keep these lines smooth and gentle. Some of these letters have a bit of an Uncial look to them. Do you see it?

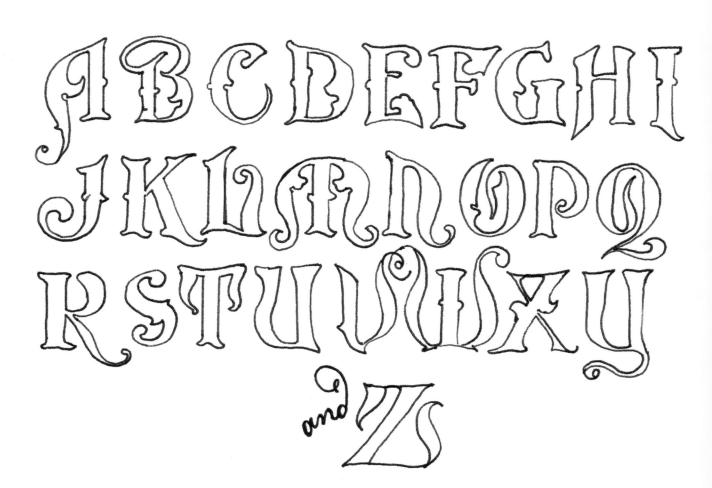

Victorian Lombardic Letters

The little half-moon shaped cutouts give these Lombardic capitals some Victorian extravagance.

A B C D E
F G H IJ K
L M N O P
Q R S T U
V W X Y Z

Whimsical Victorian Letters

These whimsical letters have character! With a definite Roman flavor, the curly serifs and little ball terminals really finish them off! For these letterforms, I was inspired by Otto Weisert designs from the 19th century.

Silhouette Letters

SILHOUETTES HAVE BEEN POPULAR SINCE THE MID-1700s when they were used to create portraits. "Silhouette" is a term used for any art piece that is backlit—a dark figure on a white background.

This project is inspired by some 19th-century embellished letters created by Julius Klinkhardt from the *Bibliothèque des Arts Décoratifs* in Paris. For these initials, choose a single classic roman letter, and then embellish it with black filigree decorations, foliage, and more!

STEP ONE Choose an initial from the classic roman alphabet on page 97 and sketch it in pencil. Once you're happy with the sketch, grab your preferred ink pen (mine is the Tombow® calligraphy marker), and start adding embellishments. On the letter "E," the ideal starting point for embellishing the letter is the left side of the stem. I add a cherub surrounded by filigree and decorations. (See page 107 for embellishment ideas.)

STEP TWO Continue to embellish the letter, building up and out. It looks best when the flourishes follow the direction of the letter. For example, the arms of the "E" point to the right, so draw the designs flowing toward the right.

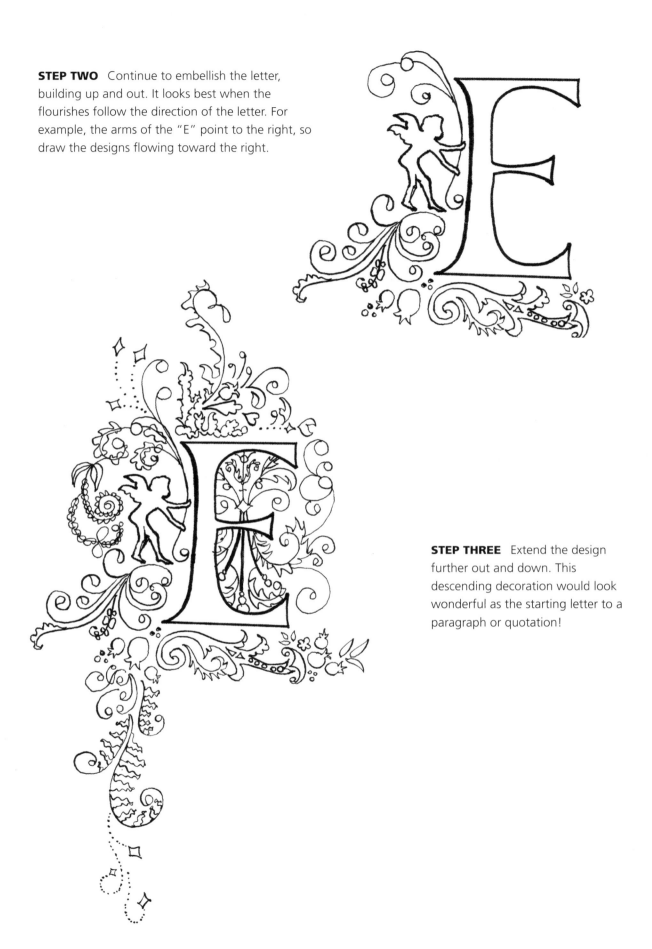

STEP THREE Extend the design further out and down. This descending decoration would look wonderful as the starting letter to a paragraph or quotation!

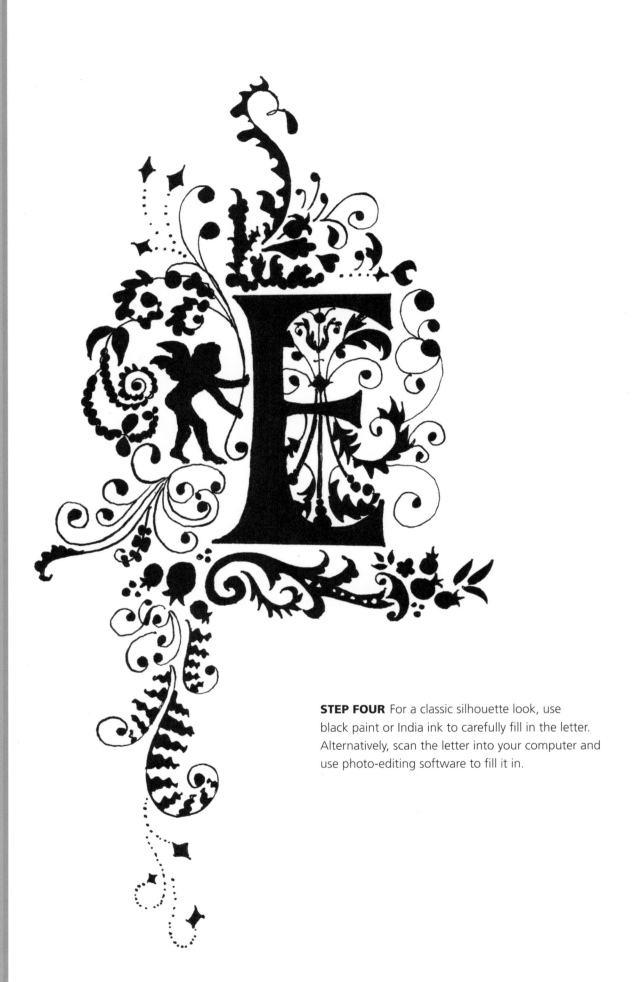

STEP FOUR For a classic silhouette look, use black paint or India ink to carefully fill in the letter. Alternatively, scan the letter into your computer and use photo-editing software to fill it in.

Embellishments

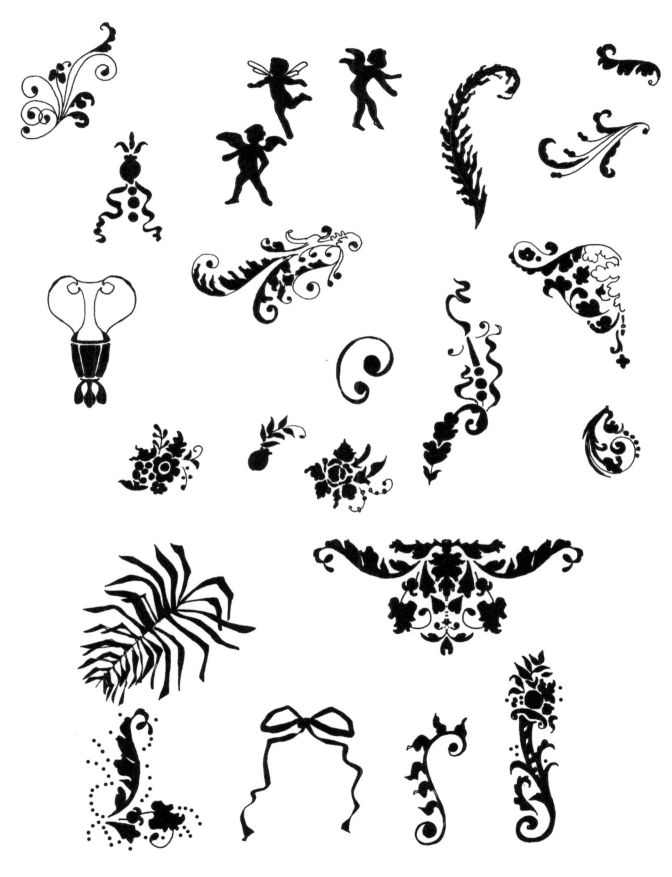

Victorian-Inspired Story Letters

FOR THIS PROJECT, WE'LL CREATE A DECORATED "STORY" LETTER in watercolor. Story letters were popular in Victorian newspapers and magazines. This letter features a cheeky dragon curled up inside the counter space, ready to blow a puff of smoke!

STEP ONE Sketch the letter on draft paper in pencil. You may need to sketch several times to get the proportions and shape just right!

STEP TWO Inside the letter, I add elegant little circles moving from small to large. Outside the letter, add some swirls and curlicues, anchored by a straight line along the stem of the letter and descending below it.

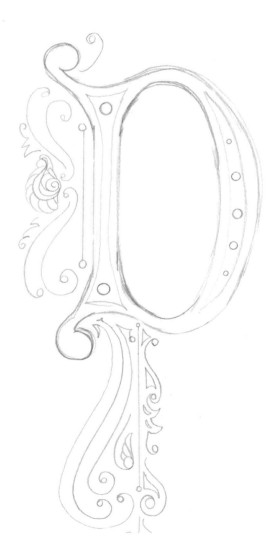

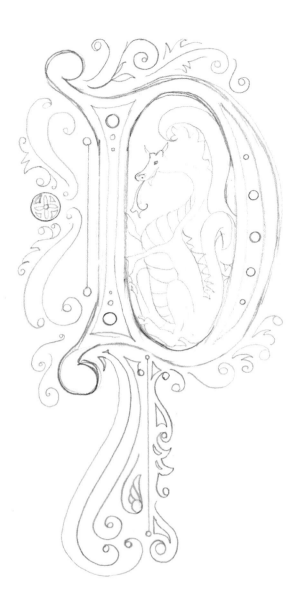

STEP THREE Time to add the dragon! I drew mine sitting comfortably inside the counter space.

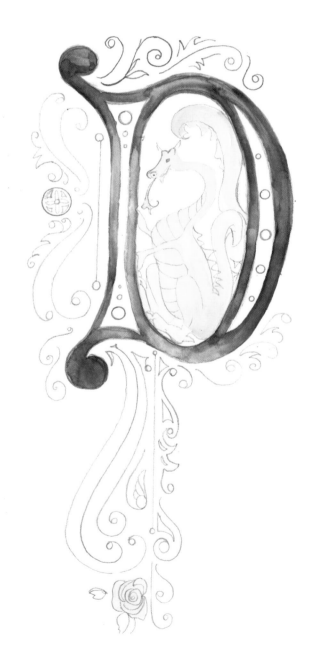

STEP FOUR With watercolors and a medium-sized brush, start with the lightest colors first. I add a layer of yellow on the dragon and the rose at the lowest part of the descending decoration. Then I add a preliminary layer of dark blue-gray to fill the letter.

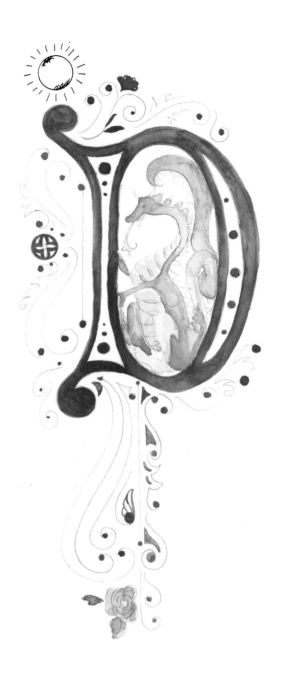

STEP FIVE Once the yellow layer is dry, use a variety of greens to add depth and shadow to the dragon. I add a little sunshine to assist with placing the cast shadow. I envision the sun shining from the upper left-hand corner—so all the shadows will be at the lower right-hand side. Add shadow to the chest and belly area with darker orange shading over the yellow.

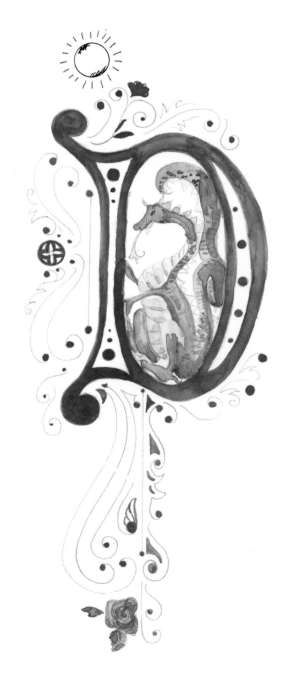

STEP SIX Add more dark tones and shadows by mixing your greens with dark blue and brown. Add these in the dragon's cast shadow area.

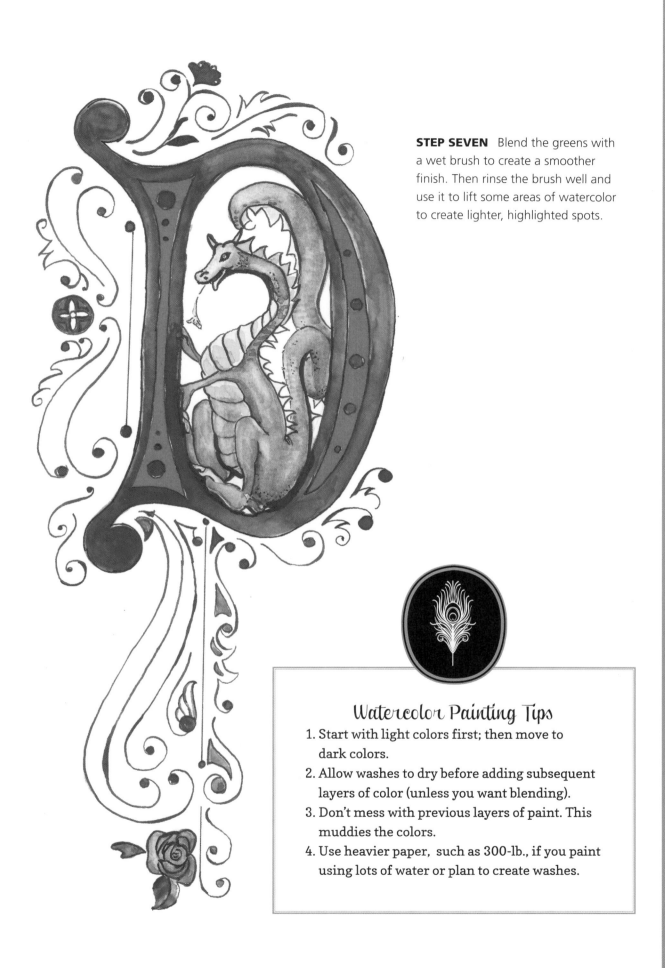

STEP SEVEN Blend the greens with a wet brush to create a smoother finish. Then rinse the brush well and use it to lift some areas of watercolor to create lighter, highlighted spots.

Watercolor Painting Tips

1. Start with light colors first; then move to dark colors.
2. Allow washes to dry before adding subsequent layers of color (unless you want blending).
3. Don't mess with previous layers of paint. This muddies the colors.
4. Use heavier paper, such as 300-lb., if you paint using lots of water or plan to create washes.

Victorian-Inspired Watercolor Lette

This whimsical watercolor letter takes a softer approach to illuminated Victorian lettering. Unlike the previous project, it doesn't tell a story, but it would make a beautiful statement for any illuminated manuscript page.

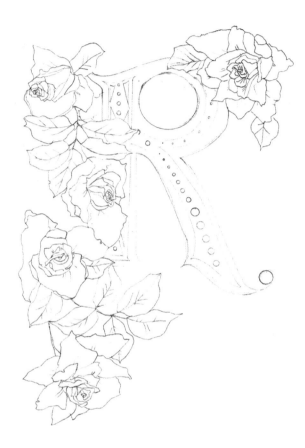

STEP ONE Work out your design on drawing paper first, and then transfer it to watercolor paper. Or you can work directly on watercolor paper from the start. Sketch the letter first, and then add florals or leaves around the letterform.

STEP TWO Working on watercolor paper, apply light washes of color to fill the letter and its outline. Add initial washes of color to the florals. Remember that watercolor paint spreads easily, so work on dry paper to keep the paint within the outlines.

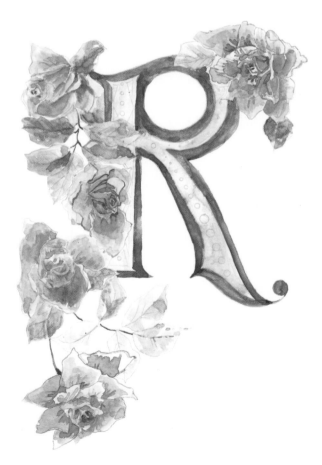

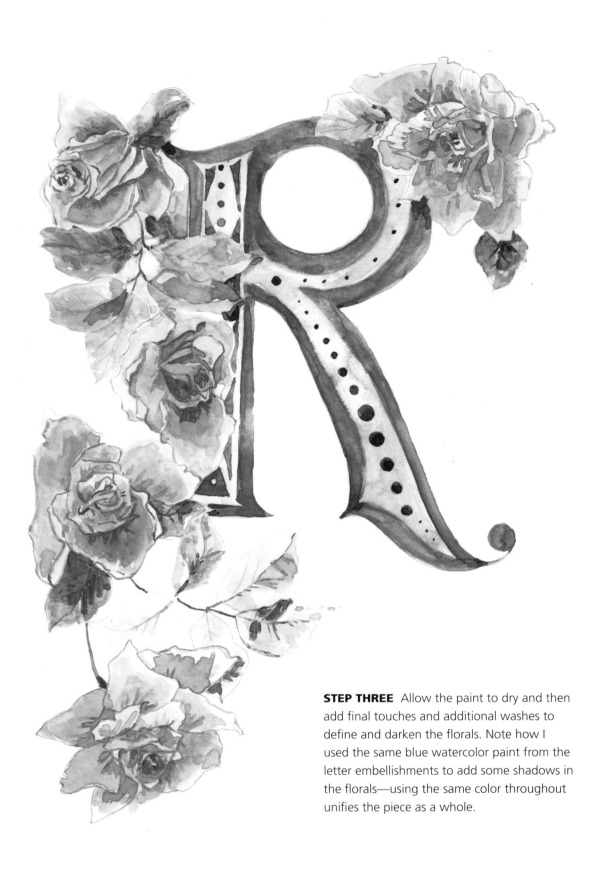

STEP THREE Allow the paint to dry and then add final touches and additional washes to define and darken the florals. Note how I used the same blue watercolor paint from the letter embellishments to add some shadows in the florals—using the same color throughout unifies the piece as a whole.

Art Nouveau Capitals

A POPULAR ART STYLE FROM THE LATE 19th-to early 20th-century, Art Nouveau design is known for sinuous, flowing shapes and elegant flora and fauna.

Art Nouveau Specifics
- Stylized, decorative letters
- Embellished swashes
- Very high or low waistlines
- Diagonal or triangular counters and letter shapes
- Flowing, rounded shapes

Classic Alphabets

Let's begin by looking at some letters that are classically Art Nouveau. I drew these letters from quintessential Art Nouveau typefaces. Note the high and low crossbars!

ABCDEFGHI

JKLMNOPQ

RSTUVWXYZ

1234567890

Böcklin Hand

These letters are a simplified version of a typeface designed in 1904 by the Schriftgiesserei Otto Weisert type foundry. It was named for a symbolist painter from Switzerland, Arnold Böcklin.

ABCDEFGHIJ

KLMNOPQRS

TUVWXYZ

1234567890

*Sometimes, fixing a lettering mistake involves getting creative.
Can the mistake be changed into the letter it was supposed to
be? For example, if you wrote an "I" but needed a "d," perhaps
the semicircle of the "d" can be added to the stem of the "I".*

Working with Color

The Art Nouveau style generally employed a limited color palette to give the art unity and cohesiveness. Try replicating one of the Art Nouveau alphabets shown on the previous pages. Then use paint or markers to add color to your work using the historically inspired palette below as a guide! Turn to page 118 for step-by-step instructions for creating a Böcklin-inspired letter.

Embellished Art Nouveau Letter

Select a letter from the alphabets on page 115 or 116, or follow the steps below to create Böcklin-inspired "J."

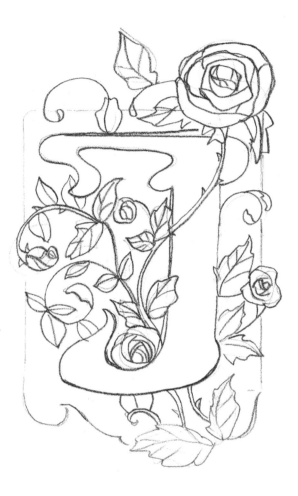

STEP ONE Sketch the letter in pencil, and then add foliage, such as roses that weave in and out of the letter. Border the letter with a frame. In keeping with the Art Nouveau style, keep all the corners round.

STEP TWO Transfer the sketch to a clean sheet of paper and outline in heavy black to create the Art Nouveau flavor we are looking for! I use a black Tombow® lettering pen, because it allows for pleasing thick-and-thin line transitions, which add interest.

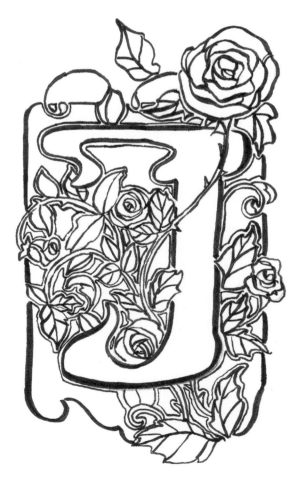

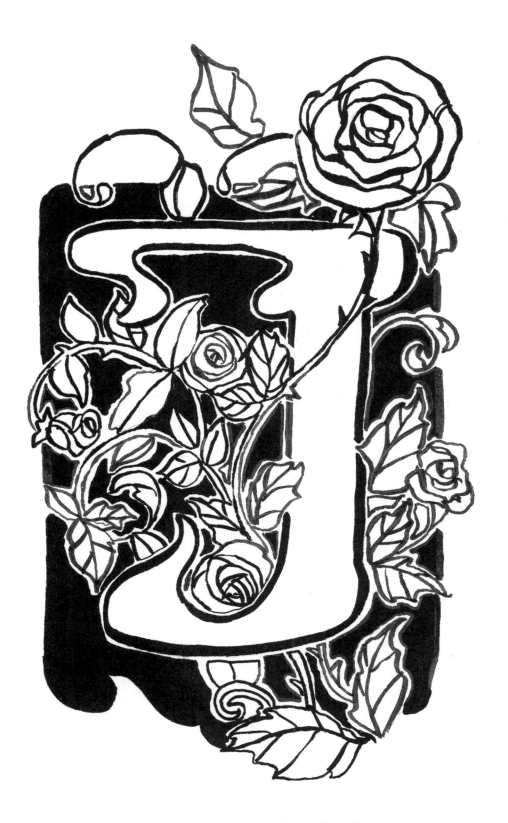

STEP THREE As you outline, imagine a stained-glass window—all the shapes that make up the piece are separate pieces of glass. That's the look you want to achieve.

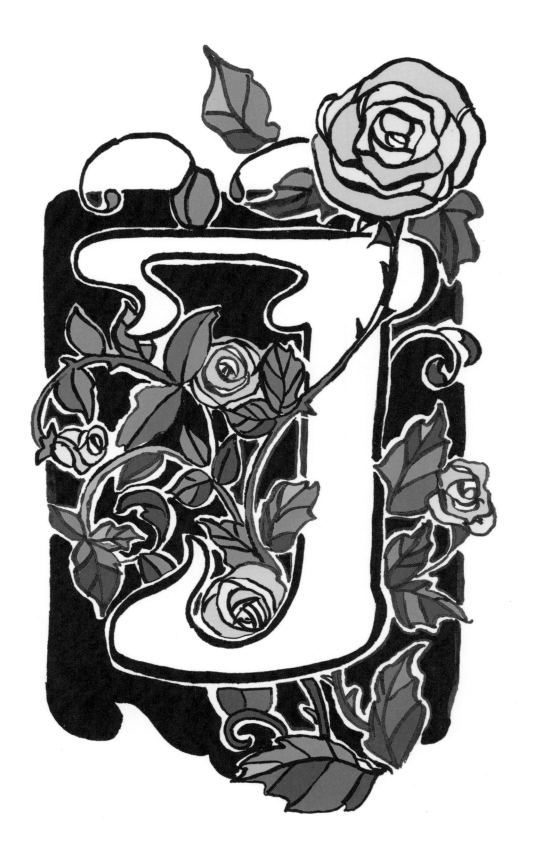

STEP FOUR Now add color. You may scan the inked page and import it into a photo-editing program or color by hand using paint or markers. Add color from an Art-Nouveau palette (see page 117), adding different shades of the same colors to the leaves and petals for depth and interest.

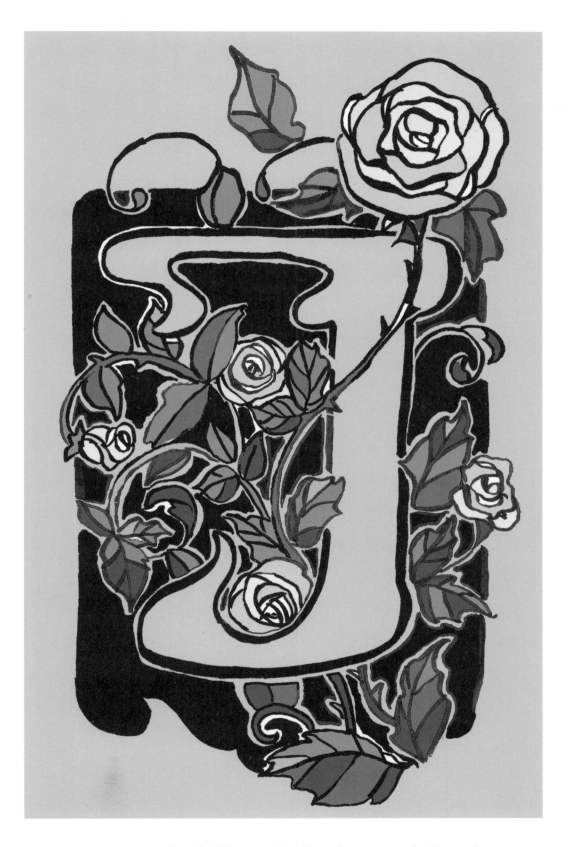

STEP FIVE For a finishing touch, I add a pale gray-green background.

Gothic Style

DURING THE GOTHIC PERIOD, THE DEMAND FOR BOOKS GREW AT A FAST RATE, and private book artisans began using letters to decorate elaborate books. The elegant main letter would highlight the beginning of a passage, coordinating with thick, intricate borders and illustrations. Each page was a veritable work of art.

For our look at Gothic letters, we will focus uniquely on the Lombardic style. English calligraphy scholar Edward Johnston (1872–1944) gave these rounded "Uncial-flavored" letters this name.

Lombardic Alphabet

This Unical-inspired alphabet is fun to embellish. Make dots large (as in the "A"), small (as in the "X"), or leave them off altogether (as in the "P"). Try dressing up the serifs with curlicues (as in the "E").

A B C D E
F G H IJ K
L M N O P
Q R S T U
V W X Y Z

Stem lines curve inward

Keep the lines of the letter stem curving in toward each other in a concave fashion.

Basic Gothic Forms

The letters below are grouped according to similarities in construction. In the top row, the letters have straight diagonal stems. In the second group, the letters have straight vertical stems. The third group is based on the circle. The letters in the fourth group feature a vertical stem with concave lines.

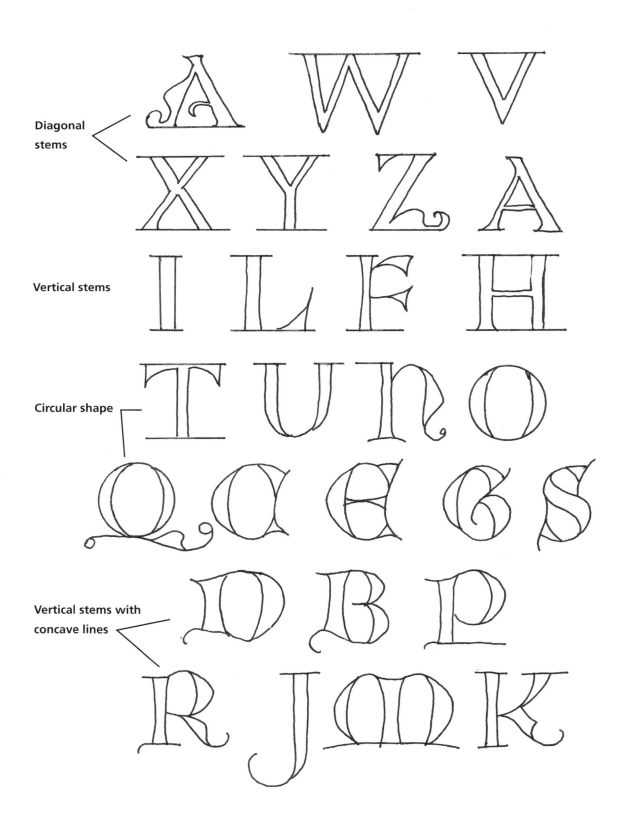

Diagonal stems

Vertical stems

Circular shape

Vertical stems with concave lines

Embellish a Gothic Letter

First, select a frame for your letter, choosing a shape that fits the letterform. Add color to the negative space inside the frames, if desired. Filling the frame with color is an excellent way to emphasize your letter.

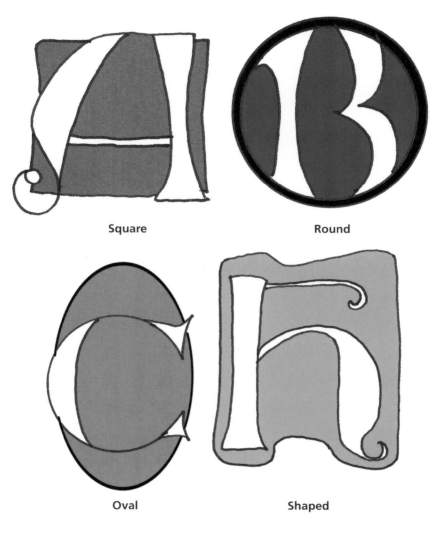

Square **Round**

Oval **Shaped**

Pointed Square

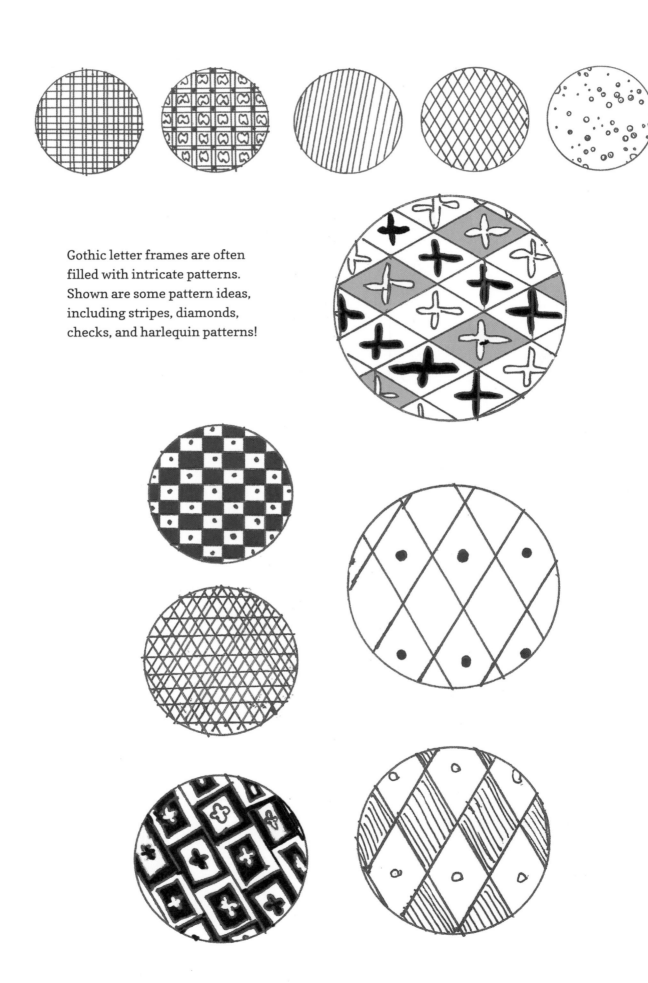

Gothic letter frames are often filled with intricate patterns. Shown are some pattern ideas, including stripes, diamonds, checks, and harlequin patterns!

Use grid lines to help you create interesting diamond and triangle pattern designs.

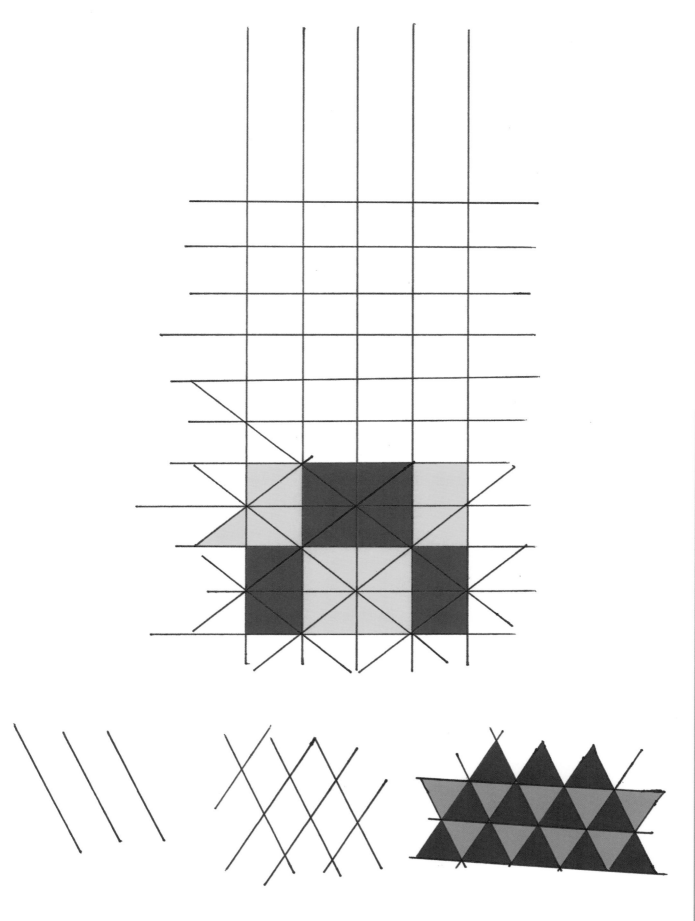

Once you've chosen a letter and have the frame and background in place,
accentuate the letter with embellishments and designs of your choice.

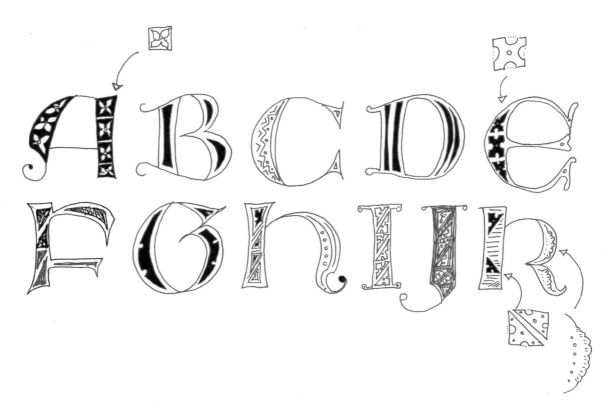

Below are four common gothic letter decorations. Even seemingly complex designs
are quite simple if you just take it step by step.

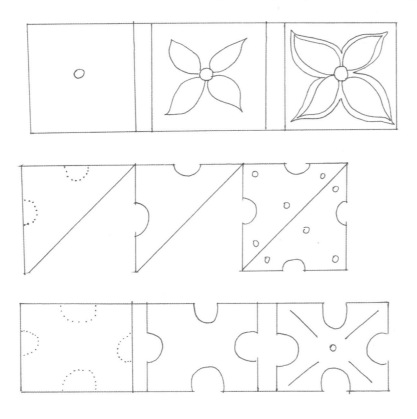

A scallop shape is perfect
for embellishing curved
parts of a letter.

Adding Color

For an authentic historical look to your letters, choose bright red (such as cadmium red), bright blue (such as ultramarine blue), white, black, and gold.

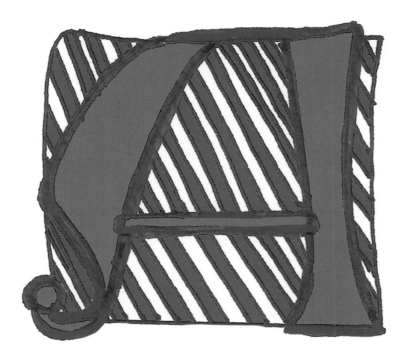

Here, the letter "A" is enclosed by a loose square shape. I added freehand stripes to the background and colored them in with bright blue. I filled in the letter with a golden shade.

This letter was inspired by floral medieval letters. I drew the letter on lavender paper with a marker. Then I filled the square frame with solid black to make the letter and flora really stand out. To decorate the background, I added heather florals and greenery.

Also inspired by floral medieval letters, I drew this letter "B" with a marker, and then scanned the artwork into my computer for coloring.

Use this woven Celtic knot for the stem for any letter you would like to have some additional flair. To create the knot look, carefully draw the strands in the correct position!

Gouache Floral Letter

STEP ONE Choose a letter from page 123. Lightly sketch your letter using an HB pencil.

STEP TWO Use gold gouache to replicate gold leaf. To make the gold really pop, first add a layer of yellow.

STEP THREE Once the paint is dry, apply a layer of gold gouache. Add vermillion red to the petals, leaving space in the rose to show the details. Paint the leaves and stems with bright viridian green washes.

131

STEP FOUR Next apply cobalt blue to the letter followed by another layer of gold gouache.

STEP FIVE Now add in white embellishments to the letter body using a fine paint pen or a small size 00 paintbrush. Add a bit more yellow gouache for highlights.

STEP SIX Outline the letter with a fine black pen
to make the various elements of the letter pop!

Voilà! An elegant homage to these beautiful floral lombardic letters.

Illuminating

I created these letters with gouache and 24-karat gold guild. I used special guild glue to affix the gold leaf to the paper prior to adding paint.

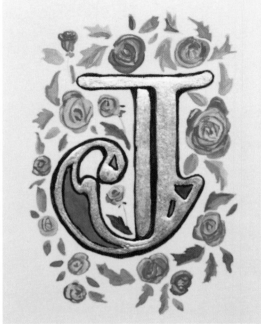

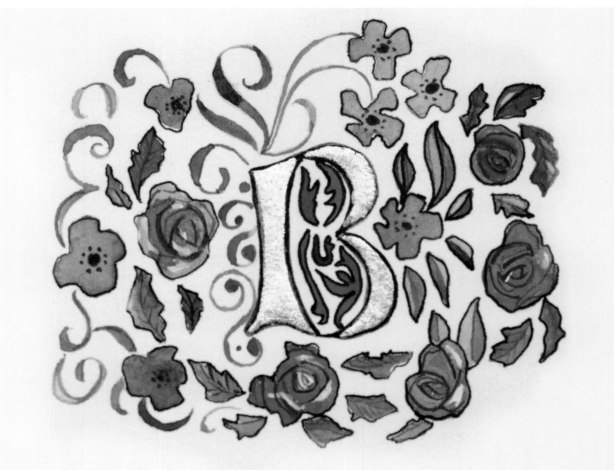

Illuminated Manuscript Page

Choose a passage from a favorite book or poem; then use your pointed pen to create a large decorative capital letter, followed by the text. Below are some ideas to get you started.

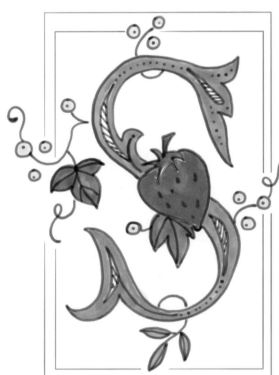

Practice Templates

Glossary

Ascender: Line that goes above the x-height.

Baseline: The line upon which the letters rest.

Calligraphy: Literally means "beautiful writing." From the Greek word *calli* ("beautiful") and *graphein* ("to write").

Crossbar: Horizontal stroke in a letter.

Descender: A line on the letterform that goes below the x-height.

Downstoke: The downward push of the pointed pen. This is the heavy stroke of the pointed pen, as the weighted lines are made on the downstrokes.

Ductus: The set of strokes that makes up a calligraphy letter.

Entrance Stroke: Hairline stroke that begins a letter. Used as a connective stroke.

Exemplar: A calligraphy alphabet.

Font: A type style.

Gouache: Opaque watercolor paint.

Hairline: The very thin strokes created with pointed pen, when no pressure is placed on the nib. Often on an upstroke.

Hand: A group of handwritten letters.

Ligature: Linking two or more letters with a stroke.

Majuscule: Large capital letter.

Minuscule: Small lowercase letter.

Serif: Decoration added to the end of a horizontal stroke. Adds legibility, horizontal alignment, and decoration.

Stem: The upright bar of a letter.

Stress: Where the weight is placed in Roman letters.

Upstroke: Upward line with the pointed pen. There is very little pressure on the pen on an upstroke. This create a thin, light hairline stroke.

X-height: The height of a minuscule "x" in a given hand. All other minuscule letters in a hand are based off this height.

Resources

Below is a list of resources I used to help me with this book. Many of them are in the public domain and can be found easily with an Internet search.

D.T. Ames, *Ames compendium of practical and ornamental penmanship* (New York, 1883)

Ludovico Arrighi, *Operina* (Rome, 1522) (*First known writing manual)

John de Beauchesne and John Baildon, *A booke containing divers sortes of hands* (1570)

Engraved by George Bickham, *The Universal Penman* (London, 1743)

Martin Billingsley, *The pens excellencie or the secretaries delighte* (1618)

Amédée de Bourmont, *Lecture et transcription des vieilles écritures* (Caen, 1881)

Sue Budden, *Alphabets Decoratifs*, L'Aventurine (Paris, 1995)

Giovanni Francesco Cresci, *Essemplare di più sorti lettere* (Rome, 1560)

Alfred Fairbank and Berthold Wolpe, *Renaissance handwriting: an anthology of italic scripts*, Faber and Faber (London, 1960)

Carol Belanger Grafton (Ed.), *Fanciful Victorian Initials*, Dover Publications (New York, 1984)

Juan de Icíar, *Arte subtilissima* (Oxford, 1960).

E.A. Lupfer, *The Zanerian Manual of Alphabets and Engrossing*, Zaner-Bloser (Ohio, 1895)

Charles Paillasson, *L'arte di scrivere: tratta dal dizionario d' arti e mestieri dell' encyclopedia metodica* (1796)

Giovanni Battista Palatino, *Libro nuovo d'imparare a scrivere* ("New Book for Learning to Write") (Rome, 1540)

Enoch Noyes, *Noyes Penmanship*, Jenks & Palmer (Boston, 1839)

Margaret Shepherd, *Learn Calligraphy: The Complete Book of Lettering and Design,* Watson-Guptill (2001)

Platt Rogers Spencer, Sr., *Compendium of Spencerian or semi-angular penmanship* (New York, 1866)

Platt Rogers Spencer, *Theory of Spencerian Penmanship,* Mott Media (Michigan, 1874)

Spencerian Authors, *New Spencerian Compendium* (1879)

About the Artist

aura Lavender, coauthor of the best-selling *Creative Lettering and Beyond: Inspiring tips, techniques, and ideas for hand lettering your way to beautiful work of art*, has worked as a calligraphy scribe, illustrator. and designer since 2008. In that time, she has designed for greeting card companies, big brands, book publishers, and fashion designers. Clients and publications that have featured her work include *The New York Times, NBC Universal, Vogue, Nordstrom, American Greetings, Bravo, Fox Searchlight Pictures, The Pioneer Woman,* and *Style Me Pretty*. Laura lives on Vancouver Island in Canada and holds a Bachelor of Fine Arts degree. Visit lauralavender.com.

ALSO IN THIS SERIES

978-1-60058-247-9

978-1-60058-372-8

978-1-60058-397-1

978-1-63322-016-4

978-1-63322-164-2

978-1-63322-339-4

978-1-63322-392-9

Visit www.QuartoKnows.com

144